Edvard Munch

A Selection

MUNCH

When Edvard Munch died on 23 January 1944, the City of Oslo inherited his rich and comprehensive collection of works. Taking care of this art treasure, and making it accessible to a wide audience, is Munchmuseet's fundamental task. In this book, we have chosen some highlights from the museum's collection. Deciding what should be included in such a small selection is not easy, as Munch created many fantastic works, and had an enormous output. The collection consists of nearly 27,000 individual pieces – roughly 1,200 paintings, 18,000 graphic prints and thousands of drawings, as well as photographs and sculptures.

Munch wrote his will bequeathing all of this to the City of Oslo in 1940. At his death, the task began of assessing all of it and planning his museum, which eventually opened in 1963. The museum also contains a great deal of other material connected to his artistic work and life, and all in all, this is one of the most comprehensive gifts ever to be donated by an artist. Munch chose not to sell the works that ended up in the museum, in order that they could benefit the whole of society as a collected statement of his vision and creative process. The works you will see in this book come, therefore, directly from Munch himself, without having been vetted by purchasing committees and collectors.

Edvard Munch believed that his art belonged in public in his homeland, not just on the walls of bourgeois living rooms. As soon as he became financially independent, he therefore chose to keep his paintings and sell mainly prints. He also became interested in the décor of public spaces and made large murals both for the University Aula and the workers' cafeteria in the Freia chocolate factory, both in Oslo. In Munch's eyes, the paintings only started to make sense when viewed next to one another. By gifting his art to Oslo, he succeeded in creating meaningful juxtapositions of the works as well as making them available to the public. Another reason why Munch held on to large parts of his artistic output was that he needed to be surrounded by the pictures in order to create. He could make new versions of central motifs over and over again, in a process that sometimes extended over several decades. He never stopped exploring new possibilities in his main body of images.

In the selection we have put together here, you will find many of Edvard Munch's most important and iconic images. These include what is possibly his most important series, The Frieze of Life, which he developed during the 1890s and exhibited in constantly changing configurations. In this painted frieze, which in his words dealt with 'the modern life of the soul', he looks at human existence and its various encounters with death, angst and love. Paintings such as *Scream, Angst, Death in the Sickroom, Madonna, Vampire, Summer Night. The Voice, Kiss, Red Virginia Creeper, Metabolism, The Dance of Life* and *Ashes* all form part of the frieze. When he began making graphic works in 1895, he created new versions of many of these same motifs as prints, including *Madonna* and *The Kiss IV*.

Judging by the selection in this book, it's clear that Munch worked with traditional image genres such as portrait, nude and landscape. These entered into the genre hierarchy as codified by the newer art academies from the Renaissance onwards. Within this system, the portrait was one of the highest-valued genres, and Munch was unparalleled here. Much of his artistic reputation – in his own time as well as afterwards – is based explicitly on his skills as a portraitist. We can see examples of this in the full-length painting of Dagny Juel Przybyszewska, the lithograph of August Strindberg and the melancholy motif featuring his sister Laura. The small *Head of a Dog* can easily be seen as a subtle, almost mocking comment on the entire portrait genre. Munch also made self-portraits for most of his lifetime. In this selection these are represented by, among others, his first ever self-portrait, which he painted at the age of around eighteen, and the striking *Between the Clock and the Bed*, which he painted when he was almost eighty.

The human nude has been a recurring image in Western art since antiquity. Munch drew and painted models from life during his whole artistic career. His first significant nude picture is *Puberty*, and many of the later nudes are among his most ambitious works from a painterly perspective, such as *Weeping Nude* and *Model by the Wicker Chair*. In *The Artist and His Model*, the ageing Munch explicitly portrays his own relationship with the young female model in a way that expresses both erotic attraction and self-irony. Even with his male nudes, Munch stretches himself to the limit, particularly in the vital *Bathing Young Men*. Another powerful and vibrant male nude is the full-length portrait of Sultan Abdul Karem in *Cleopatra and the Slave*.

Landscape, first recognised as its own pictorial genre in the eighteenth century, was also important for Munch. Within this type of painting, we can also find some of his most iconic, striking motifs, such as *Starry Night* and *The Yellow Log*. In Munch's full-size mock-up for the University Aula, we find landscape imagery on a monumental scale, with *The Sun* and *The Researchers* forming elements of a larger narrative concept about human life on Earth in a gigantic, unexplainable universe.

The artworks in this book also reveal Munch's interest in form. This applies partly to his innovative emphasis on the process of painting, the painted surface and the actual brushstroke. We can see this in different ways in works such as Puberty, the portrait of Stanisław Przybyszewski, *The Death of Marat* and *Cupid and Psyche*. Another side of Munch's interest in form is visible in lively and dynamic compositions which practically leap out of the picture frame. Examples of this are *Workers Returning Home* and *Galloping Horse*. Munch was ceaselessly experimental, exploring the tension between figuration and abstraction. His willingness to experiment is also apparent in his prints, and notably prominent in the most abstract version of *The Kiss*, where the motif is reduced to an emblem – the two figures melted together into a single dark, amoebic shape.

Edvard Munch has created iconic works that have gone on to become a part of our global visual culture. Perhaps this is because his works express feelings familiar to most people, which they can relate to in several different ways. It probably also has something to do with Munch's tireless efforts to expand the

frontiers of what it was possible to communicate in an artistic medium. In any case, his pictures are certainly still capable of exciting a wide audience, both in Norway and abroad.

Jon-Ove Steihaug
Senior Curator, MUNCH

Edvard Munch has painted a large number of self-portraits, in keeping with famous colleagues such as Rembrandt and Van Gogh – whom he admired. Artists have a tendency to be self-absorbed, without that necessarily being the main motivation; they have a continuous need for a model, for instance, and the easiest available, cheapest and most willing candidate is often oneself.

Munch's little picture is a classic self-portrait – in more than one sense. He enrolled in the Royal School of Design in autumn 1880, after having left the Technical College in the spring of the same year. At both schools the teaching method was based on classical art and the Italian Renaissance as ideal and inspiration. In 1881 the Kristiania Sculpture Museum opened its doors as well; there the public and artists could admire plaster casts of many famous works from Antiquity.

The little self-portrait depicts the head and shoulders, like a classical bust. The head is in semi-profile, which increases the sense of spatial depth in the shapes of the face. The bright light issuing from the left creates contrasts in light and shade, which also contribute to describing the form. The face is meticulously painted in every detail; with a fine brush, for instance, the eyelashes are made visible in one of the eyes, where they capture the light against a darker eyeball. The gaze is sidelong so that the young man looks directly at the viewers. Or – if we imagine Munch with brush in hand: He meets his own gaze as he studies his face in the mirror.

Munch has reproduced his own mirror image with precise shapes and clear lines, and in this way followed the "classic" prerequisites. The colours play a secondary role; the entire lit-up portion of the face is rendered in a pale and rather monochrome tone, for instance. However, this picture was soon followed up by a number of new portraits and studies of landscapes, in which Munch explored composition, colour schemes and brushstrokes in an increasingly self-assured, free and bold manner.

Munch's little self-portrait soon found its place on the living room wall at home, together with other family pictures and, in time, additional paintings by the young artist. The museum received this picture as a gift from the artist's sister, Inger Munch. Her inscription on the reverse side states that it was painted in 1882.

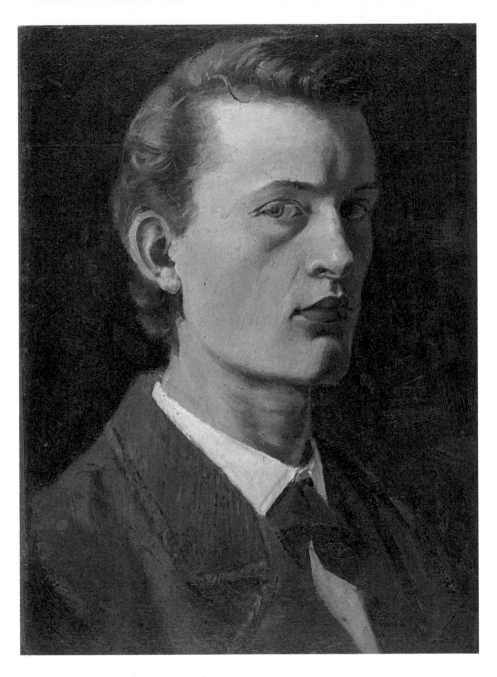

Self-Portrait (1881–82)
Oil on paper mounted on cardboard
26.5 × 19.5 cm

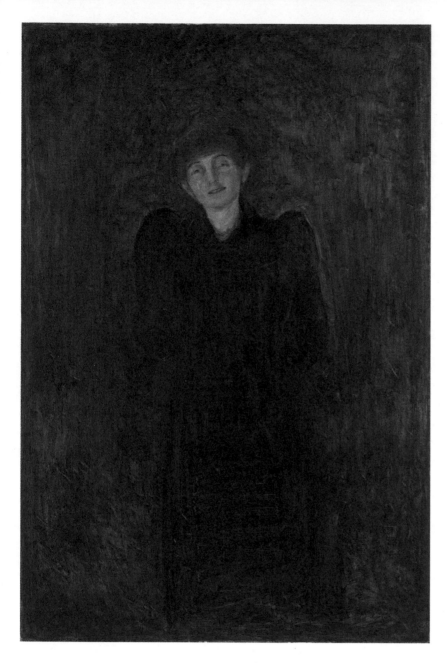

Dagny Juel Przybyszewska (1881–82)
Oil on canvas
149 × 100.5 cm

It is a highly sympathetic representation of the Norwegian writer and pianist Dagny Juel Przybyszewska (1867–1901) that we see here. The warm smile and the gracious expression allow us to sense the intimate friendship shared between her and Edvard Munch. They became acquainted in the years around 1890, in Kristiania, and met again in Berlin when Dagny arrived in the city in the spring of 1893. According to Munch, it was her literary interests that lay behind their spending so much time together. He described her as "a Lady with strong literary and artistic interests".

In addition to her own artistic activities as a pianist and writer, Przybyszewska also became an important promoter of Norwegian art abroad. She translated books by Norwegian writers and articles about Norwegian art into German, and translated German texts into Norwegian. She assisted her husband, Stanislaw Przybyszewski, in publishing reproductions of and texts about Norwegian art in European journals. In addition, she helped Munch in mounting exhibitions and selling his art, and she took the initiative to organise new exhibitions. Munch remembers how "she translated Norwegian Books and was helpful and supportive, whenever she could. I even remember how, during the final Days before my Exhibitions in Berlin opened, she took almost more initiative than I, and helped with the hanging and arranging".

Przybyszewska was one of Munch's few close female friends capable of challenging him professionally. When he paints her, it is in full length in a large format. The pinned-up hair accentuates the facial features – such as the distinctive dark purple eyebrows and the red lips. Even though she is apparently standing still, with her arms behind her back, there is something restless about the composition. The head is tilted, and together with the many brushstrokes of thinly layered paint around the body, she seems to be moving. If we take a closer look at the head, we also discover several halo-like lines, similar to those in *Madonna*. The halo and the hazy background give the portrait a somewhat religious and otherworldly character. By depicting the body as nearly dissolving and melting into the background, Munch attempts to create an unusual atmosphere around her. The indistinct background also causes the more developed face to appear to "jump out" of the picture. This feeling is intensified by the warm hues of the skin, in contrast to the dark dress and background. Munch may have had a penchant for this effect, since he chose a similar approach in *Self-Portrait with Cigarette*.

Przybyszewska and Munch remained close friends and kept in frequent contact up until her unexpected death in 1901, when she was shot by a jealous lover in Tbilisi, Georgia. The incident made a strong impression on Munch, who wrote a gripping eulogy in Kristiania Dagsavis. He was very fond of the portrait of his friend, and had it hanging in his living room at Ekely for 20 years.

Something is happening there, in the chair in the background – but we are denied a proper view of the chair's occupant. Instead, we have to be content to look at the ornamental back of a wicker chair. All we can make out is the corner of an enormous pillow and an arm dressed in white linen, and a tiny part of a hand. Both arm and hand seem to rest heavily on the seated person's knees, which are covered by a dark blanket. The other people in the room seem to be better informed than us – apparently they know exactly what is going on. Their faces and postures reflect the graveness of the situation, and the vacated bed and medicine bottles tell us the rest: something dramatic is happening. Like the chair, the seated person has turned his or her back to us, signalling that there is nothing we can possibly do. Destiny must be faced alone.

The family members in the foreground also seem to be alone – alone with their feelings. There are so many raw emotions directed towards this chair – despair, sorrow, resignation, frustration and maybe even guilt – that it is almost impossible not to project our own experiences of sickness, disease and death onto the painting as well. Before we know it, the back of the chair – essentially reed and cane – becomes a symbol of all the sadness and horror evoked by someone dear dying.

Edvard Munch was fully aware of the potential power of each and every detail of his art. Around 1880 he recorded in an illustrated journal that art has to be about the human aspect, about life, and not dead nature. He exemplifies his thought by a reference to a chair:

> *A chair can be as great*
> *of interest as a human being*
> *But the chair must be seen by a human*
> *It must in some way or other*
> *have moved him and one must*
> *cause the viewers to be moved in the same fashion*
> *It is not the chair that must be painted*
> *but how a person has experienced it*

Knowing this painting, having felt the enormous pain linked to the back of the chair; will we ever be able to see a beautiful wicker chair only as an object kept in the museum's collection?

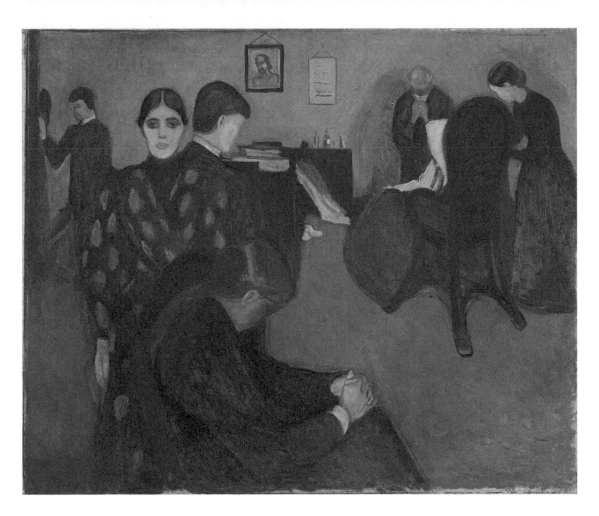

Death in the Sickroom (1893)
Oil on canvas
134.5 × 160 cm

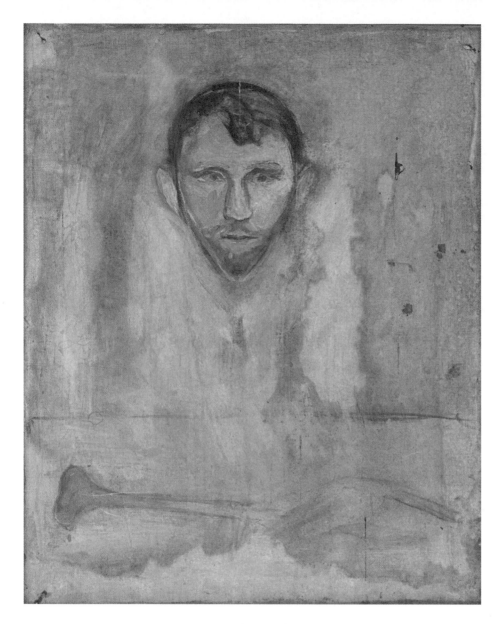

Stanislaw Przybyszewski (1894)
Casein and distemper on canvas
75.5 × 60.5 cm

We gain a sense of the Polish author Stanislaw Przybyszewski's (1868–1927) eccentric personality in this unusual portrait, in which the head seems to hover – as though he exists in his own remote world.

When Munch met Przybyszewski in Berlin in the winter of 1892– 93, the author had made a name for himself with his essays on Chopin, Nietzsche and the Swedish author Ola Hansson. Munch and Przybyszewski developed a close friendship in the following years, and Przybyszewski married Munch's Norwegian friend Dagny Juel. He was the first to publish in-depth articles about Munch's works internationally and was a significant advocate of his art, in particular in Central Europe in the years before Munch had achieved broader recognition. Przybyszewski was known for his enthusiastic and personal intensity when he wrote, and he considered Munch as a spokesperson for what he called "the life tenets and worldview of our times". In 1894 he published the very first monograph about the artist, in which he describes Munch's painting style: "Munch's intention, in a few words, is not to reproduce a physical, naked circumstance mythologically, that is, via metaphors of the senses, but directly in its colourful equivalents, and based on this perspective, Munch is the naturalist par excellence of the machinations of the soul."

Munch spent the summer of 1894 at Filtvet, a little hamlet on the coast south of Oslo. Przybyszewski came here to visit, and had his portrait painted. Extremely satisfied, he describes the painting as "fabulous with psychic representational force". This was the first of several portraits Munch made of the author, and it appears to be the most explicitly symbolist among them: Przybyszewski's head hovers in a hazy landscape, and the skeleton arm in the lower section can be interpreted as a reference to death and life's impermanence. Both of these elements can be found in Munch's lithographic *Self-Portrait*, which he made the following year. The disembodied head can perhaps be interpreted as a symbol of the human soul, which continues to live after death, and can also be a reference to a popular motif of the time; the biblical account of Salome, who had her wish fulfilled when the head of John the Baptist was served to her on a platter. A popular femme fatale motif and a familiar theme in Przybyszewski's writing.

Munch's use of diluted paint makes it appear as though the portrait is about to disappear amidst the grey-brown hues on the uneven surface. The runny paint contributes to the stained appearance of the canvas, but it is uncertain whether this was the result of damage or an effect Munch sought after.

Munch kept the painting in his own possession, and this may be an indication that he was attached to it. His eulogy after the author's death, in 1927, also suggests the same: "My friend Przybyszewski […] with large fiery eyes in a pale face, young, enthusiastic, even into the future. Nervous and sensitive, at times high up where the eternal stars shone on him, at times quite despondent on the verge of despair, with obstructing walls wherever he turned."

"Madonna" is a recurring theme in visual art. Western art history is full of paintings with the title *Madonna*, depictions of the Virgin Mary, often with the child Jesus in her arms or on her lap. The tradition dates back to the very first Christian images in the 2nd century AD, and experienced widespread popularity in Renaissance and Baroque art. Leonardo, Michelangelo, Rembrandt and Raphael have all presented their versions of the mother of Christ and painted Madonna figures. Edvard Munch's *Madonna* distinguishes itself fundamentally from all the earlier Madonna depictions. She is not a chaste woman; but quite the opposite, an erotic woman who lusts and loves. Munch described the picture like this: "A woman who gives herself over – and acquires a Madonna's aching beauty."

In the painting, Munch depicts a woman making love without being pornographic and without objectifying her. He depicts an actual, living woman – not the myth of a sexually active woman. Munch lived during a period of transition, on the threshold of female liberation and a new view of women. Perhaps without being aware of it himself, Munch contributed to expanding the perception of a sexually active woman – he allows us to understand that it is both beautiful and natural. The formative years of Munch's life coincided with the breakthrough of the middle class women's movement. Outdated female ideals had to give way to new ones, relations between the sexes changed – and in his pictures, Munch has contributed to the liberation and renewal of the role of women. With *Madonna* he has delivered a contribution to the history of gender equality as groundbreaking as Henrik Ibsen's *A Doll's House*. Many of the women active in the women's movement during Munch's time were unmarried and, paradoxically, not in a position to fight for sexual liberation. Munch achieved what the women activists could not. He occasionally called the painting "Woman Making Love", and he wrote a short text related to the picture:

The pause when the whole world stopped in its tracks
Your face encompasses all the earth's beauty
Your lips crimson like ripening fruit separate as though in pain
The smile of a corpse / Now life offers death its hand
The chain has been linked which connects the millennium
of generations
that are deceased to the millennium that are to come

These words are associated with a vitalistic view of life, where life and death are closely linked. The German philosopher Friedrich Nietzsche exercised great influence over Scandinavian thinking and culture with his philosophy regarding "the eternal recurrence". In its wake followed a cultivation of the life forces and the physical body, in which human existence was perceived as a perpetual cycle, where life, death and sexuality are woven tightly together.

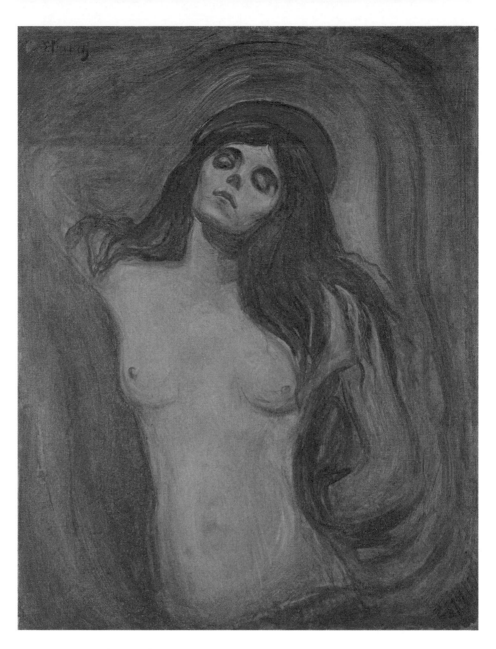

Madonna (1894)
Oil on canvas
90 × 68.5 cm

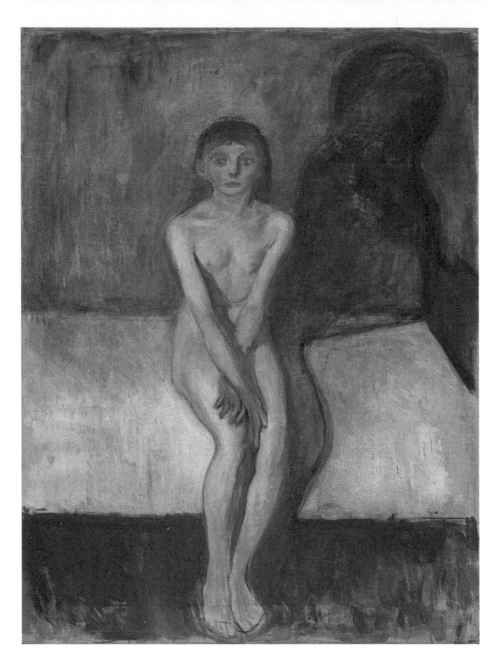

Puberty (1894)
Oil on unprimed canvas
150 × 112.5 cm

She sits on a bed holding her arms crossed in front of her, as though to protect herself. The hands rest on the thighs, which are pressed together. The gaze is directed at us, yet at the same time distant. The cool light emanating from the side falls across the chest and shoulders and on the white bedspread. A deep shadow creeps close to the naked figure and rises up in a dark and dominating shape on the wall behind her, like an amorphous doppelgänger. If we consider the picture's title, *Puberty*, the shadow might appear as a sign of something unknown and potentially threatening, a change that is about to occur.

"She" is a young adolescent girl whom Edvard Munch conceived an interest in and paid to sit for him. He painted the picture in Berlin, but that is all we know about her. We can assume that she came from a worker's family and needed the extra money she was able to earn in this way. Perhaps she was a housemaid? Young as she is, it may have been the first time she sat as a model. To undress in front of a man who was a stranger must certainly have been an unaccustomed and unpleasant experience, even though he was an artist. She could also have been a prostitute. A writer friend, Adolf Paul, stopped by to visit Munch while he was painting the picture, and later described the situation: "On the edge of the bed sat a girl in the nude, a model. She had not the look of a saint, yet seemed innocent, chaste and shy, in spite of all humiliation. It was this untouched quality that had tempted Munch to paint her. As she sat there in radiant spring sun, steeped in bright light, the shadow of her body behind her and above, threatening like fate, he was painting her with all the absorption of which he was capable."

In this painting Munch has worked with diluted oil paint that has seeped into the unprimed canvas, and the picture has a matte and delicate surface. The dark background consists of transparent, fluid layers in muddy brown, blue and green colour tones, where the structure in the fine weave of the canvas material shines through or is totally exposed. The spotted brushstrokes are in some places distinct, but in many others so washed together that the colour nuances are indistinguishable. The unevenly painted bedspread in shimmering blue, turquoise and white tones, alternates with areas where the canvas remains more or less unpainted. In other places, Munch has sprayed paint in fine drops, resulting in intangible clouds of colour. He experimented radically with an array of painterly means here, and with what they can express – in a way that makes the nude motif even stronger and more gripping.

The vulnerability that the young girl evokes – the fact of being exposed to the gaze of a stranger – is materialised physically in the thin layers of paint. The fragility of the painting's surface becomes a signpost of the psychologically heightened tension of the motif.

Apparently not exhibited until 1897, *Angst* is a key component in the serial imagery of Edvard Munch's Frieze of Life as it first appeared in Berlin in 1902. Munch placed it as the introduction to a grouping of five paintings devoted to the theme of angst or anxiety that culminated in *The Scream*. *Angst* functioned as a transition from the drastic distortions and unorthodox media mixture of *The Scream* to other images within the series devoted to love and death. It is as if Munch sought to mediate between the realms of his other paintings and the unique radicality of *The Scream*, and did so by quoting aspects of it while introducing elements derived from kindred works.

Angst fuses the landscape and dramatic sky of *The Scream* with the crowd of pedestrians of *Evening on Karl Johan* (KODE, Bergen). The setting and sky of *The Scream* were retained, as well as the sharply dissonant striations of the sunset sky. Similarly, the three foreground figures and the crowd behind them of *Evening on Karl Johan* reappear altered and are shifted closer to the foreground, as if accenting the viewer's isolation from them. Alone, the viewer is confronted by the mask-like faces of an approaching anonymous crowd, thereby generating the sense of angst of the painting title. There are notable differences stylistically as well. Most readily seen, is that the extraordinarily thin paint in *Evening on Karl Johan* and *The Scream* was used more sparingly, always brushed as thin paint films on defined, limited areas, never without the total control of the artist's brush. Nonetheless, the paint medium was applied thinly again, but is now more opaque in effect, sometimes in thin films atop one another, never permitting the canvas support to remain uncovered or shimmering through. Instead, paint is applied to accent texture, not the surface, as scumbled brushstrokes adhere to the coarse canvas nap. It is as if, after the extraordinary anti-traditional experimentation of *The Scream* and *Evening on Karl Johan*, Munch returned to more established practices even as he retained the drastic imagery and signification of them. The screaming sky of *The Scream* was fused with the menacing crowd of *Evening on Karl Johan* to generate a new mood of communal psychological distress, now not of an individual but of a generalised grouping of pallid-faced personages lacking true individuality, their eyes no more than emptily staring points or widely gaping, startled or in fear. There is no individuality but the crowd forces the painting's viewer into isolation, into being alone and incapable of communication with the confronting mass of anonymity.

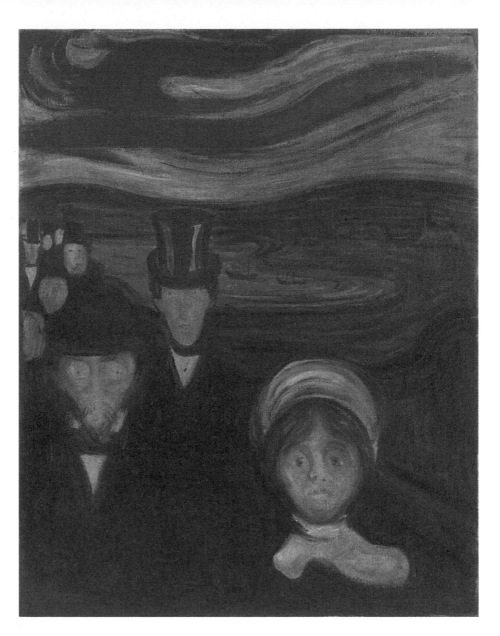

Angst (1894)
Oil on canvas
93.5 × 73 cm

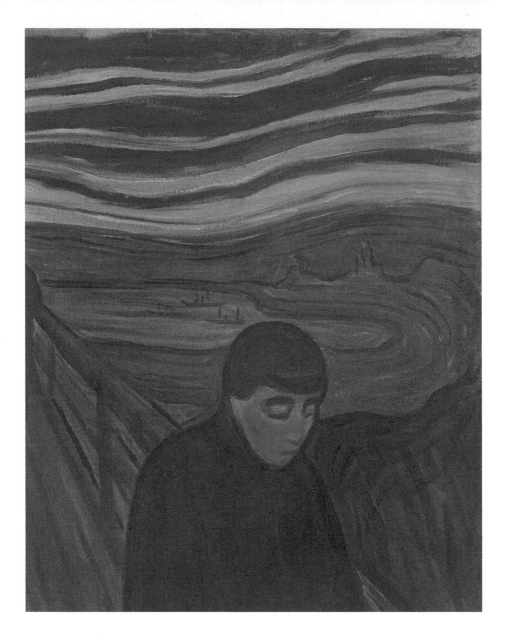

Despair (1894)
Oil on canvas
92 × 73 mm

It's as if the world has become too loud. The young man's gaze is directed downward, and the eyes are fully or nearly closed. Dressed in black and introverted, he is in stark contrast to the brightly coloured sky. The two figures we see in the background appear to be engaged in conversation, and are unaware of his dire state. Perhaps he has just experienced "the scream" after a moment of earth-shattering insight that has changed the way he sees the world – a world where light and dark are fighting a bloody battle across the firmament.

Edvard Munch painted this motif at a time marked by great change. A modern industrial society with new ideas was emerging. Criticism of Christianity and its values was accompanied by a feeling of disintegration and extinction. It's as if the young man is taken out of a contemporary novel – he might have been the protagonist of Knut Hamsun's novel *Hunger* or the student Raskolnikov in Dostoyevsky's *Crime and Punishment*. A young man who struggles with the anguish related to matters of love or big philosophical questions that he finds no answers to: What shall I believe or think when everything is falling apart? How can the others stroll along untroubled and conversing as though nothing has happened? Is the human being fundamentally alone?

We are aware that Munch worked at length on *The Scream* before he arrived, in 1893, at the iconic figure that we know so well. But did he perhaps feel that there was something he wished to convey that was not covered by *The Scream*? The sun setting over the landscape in *Despair* is very similar to both *The Scream* and *Angst*. In photographs of Munch's studio at Ekely, we can in any case see that the artist has hung these three pictures together in a group.

Despair is more distanced from the experience that is so poignantly and directly depicted in *The Scream*. In one sense, the motif is painted in the third person – the viewer experiences something via the young man. Perhaps all three pictures can be said to depict different aspects of the same experience: the direct experience (*The Scream*), how the experience influences the young man's perception of the people around him (*Angst*) and how the experience leads to numbing isolation (*Despair*).

This motif continues to feel as vital today as when it was created. The times we are living in have produced new crises, and the scream that runs through nature has only increased in intensity. It seems the world is becoming increasingly more social and open. Nevertheless, many can recognise the feeling of being lonely and isolated. There is something very familiar and modern about the young man's posture. Perhaps he is not looking downward and inward only in search of answers. Perhaps he is peeking down at his cell phone.

Edvard Munch's *Self-Portrait* is among the artist's very first forays into lithography. In it, the artist's head floats, detached, within a dense black arena, surmounting a white band reminiscent of a priest's collar, framed below by a skeletal forearm and hand and above by Munch's name and the date 1895. The overall effect is that of a tombstone, or of the face of Jesus on the Shroud of Turin. Tension is communicated by the artist's hooded eyes, which are ever so slightly out of register, and by asymmetrical eyebrows that give the two sides of the face distinctly different expressions. Tiny vertical lines are inscribed into the black surface, allowing the white paper to show through. These minute details define the space around the artist's head, but only with uncertainty: Do they reside in the foreground or background or do they erase any distinction between the two? Do they suggest a membrane through which the artist attempts to view us?

A singular trial proof demonstrates that the stark image began as a more conventional representation. In it, the artist's face and body are set within a streaked surround, suggestive of smoke or mist. In its vaporous atmosphere, and its suggestion of a shadow to the left, the print is closely allied with Munch's *Self-Portrait with Cigarette* (Nasjonalmuseet, Oslo). Munch scratched the surface of this image, creating short vertical lines that run, grid-like, throughout the entire dark area of the print. After pulling the trial proof, the artist covered the dark area between the upper band and skeletal arm with tusche, resulting in an almost monochromatic black surface out of which the head and collar now appear as though disembodied, translating the image from the observed to the symbolic. The artist, however, preserved the tiny vertical white lines, even inscribing them deliberately into later states of the print in which he over-painted the symbolic framing elements. Munch later recalled, "I have constantly worked further on my prints and experimented with different impressions ... This is similarly the case with Self-Portrait with the Hand – The Hand has been removed."

In addition to recreating himself as a post-mortem image, or perhaps a martyr or a priest, Munch made several decisions that make this image subtly disquieting: First, he wrote four letters in his name backwards – or rather frontward on the lithographic stone which, when printed, appear backwards. They may have been accidental reversals when he drew them in mirror-image fashion, but when he examined the trial proof and reworked the lithographic stone, he chose not to make the corrections. Second, the bones of the skeletal arm are articulated as though they are still connected by ligaments and tendons, or perhaps by the wires routinely used for skeletons on display for anatomical study. Finally, when Munch signed the print, he did so not in the margin, but on a forearm bone, symbolically reanimating the dead arm that paradoxically may have drawn the composition.

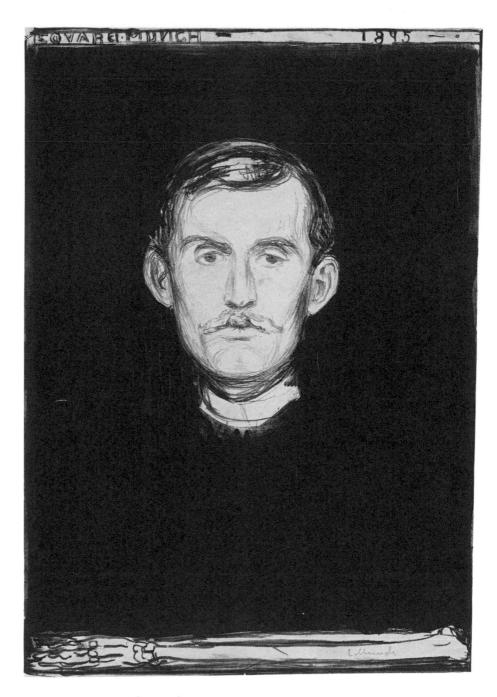

Self-Portrait (1895)
Lithograph
457 × 368 mm

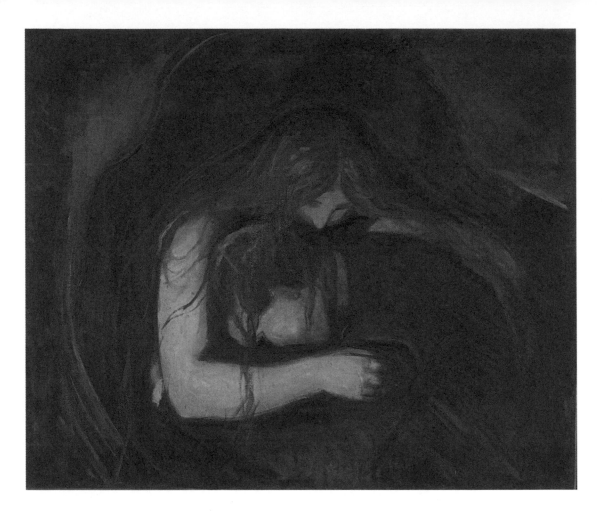

Vampire (1895)
Oil on canvas
91 × 109 cm

Powerful, long, red-orange brushstrokes creep around stealthily and engulf the two figures. The woman's hair seems to be alive as it crawls over her shoulders and arms and onto the man's head and back. The pair appear to merge together into one shape. This effect is intensified by the threatening deep shadow behind them, which replicates the contours of the couple. A dramatic atmosphere and murky light penetrate the scene. The contrasting colours, the red-orange hair and the man's pale green face against the blue-black background serve to intensify the scene. It's as though a spotlight has been aimed at the couple from the lower left. The lighting accentuates her strong arms as she embraces the man, giving the deep shadow a distinct outline, like a separate dark form against a lighter, hazy background. The shadow almost appears to rise up behind the couple like an animate creature. It becomes a feature that underscores the uneasy and precarious atmosphere. We can see similar examples in *Puberty* and *Self-Portrait in Hell*.

There is something strange about the juxtaposition of a naked woman embracing a fully dressed man. It arouses associations to prostitution and promiscuity, yet it doesn't quite work here, where the woman is the dominating and active one. It is she who holds the man in her embrace. The unusual composition and the dramatic atmosphere add an ambiguous undertone to the motif. The fact that the title of the picture had been changed is a reflection of this. The first time the picture was exhibited, in 1893, it was called "Love and Pain". This title suggests a gentle and loving relationship between two people, a woman kissing a man on the back of the neck. Perhaps it was Edvard Munch's good friend, the writer Stanislaw Przybyszewski, who inspired Munch to change the title. Influenced by the misogynist ideas of the period, Przybyszewski published his highly personal interpretation of the motif. What he saw was "A broken man with a biting vampire face on his neck", and wrote further: "But he will not be free of the vampire; and he will not be free of the pain; and the woman will always be seated there, will always be biting him with a thousand adders' tongues, with a thousand poisonous fangs." We recognise the hostile tone characteristic of the period's representations of women, where a woman's influence on a man was associated with decay and doom. Munch probably liked the description, judging from his decision to change the title to *Vampire*. At the same time, the change of title illustrates the diversity of Munch's imagery, and how a title can be decisive for what we see.

The linking of red hair with representations of the femme fatale was typical of the period. Munch created several works in which he associated red-haired women with despair or something threatening, such as *Ashes* and the lithograph *Woman with Red Hair and Green Eyes. The Sin*. He made many versions of the *Vampire* motif: two pastels and four paintings during the 1890s, and six paintings during the years 1916–25. In addition there are striking lithographs, combination prints and drawings.

We know that at least one of the earliest painted versions of *Madonna* was equipped with a wooden frame, and decorated with an embryo and spermatozoa. A comment in the humour magazine Korsaren – "The picture is framed; but the frame is most rancid" – was probably representative of how many people reacted to this highly provocative way of framing the picture. Edvard Munch therefore chose to replace it with a neutral frame rather quickly.

However, in the graphic versions the original frame lives on, not as a physical frame, but as a decorative border, integrated into the motif. The idea behind this must have been that graphic art has a different social function and a more intimate character than painting; collectors often kept their prints in portfolios, which were brought out and shown to especially interested persons. In addition, Munch had the possibility here to satisfy both "liberal" and "conservative" collectors. For many of the impressions he concealed the border during the printing process, and thus had an alternative for those who found this element inappropriate.

An important difference between the border and the lost frame is that the border does not cover the lower edge of the lithograph. The illusion of a physical frame is thus disturbed. The woman is no longer "closed in", the decorative border becomes a portal that emphasises her, sets her free.

The black and white version of *Madonna* was made in 1895, one of the first lithographic works from Munch's hand. The need for colours most likely became apparent rather quickly, and to begin with he solved the problem by hand-colouring black and white versions. Seven years later he began printing coloured versions, first with red for the border and halo – or is it a hairband? – and then blue for the undulating background. He later also applies colour to the body, primarily a light olive green, occasionally a more yellowish ochre. The coloured version of *Madonna* was thus complete. But wait a minute … where do these locks of hair that cascade over the woman's hips come from? Well, that is an addition Munch made as late as around 1913. About this he writes: "Later a very few impressions of *Woman Making Love* were printed but in order to distinguish them I have changed the drawing". This comment indicates that the locks of hair were not primarily a desire to develop the motif further, but were intended to create a clear distinction between the early and late versions. Perhaps as a gesture to those who supported him and bought the early *Madonna* prints, back when he was still a poor artist.

Most of Munch's graphic works were printed in relatively small editions. One exception is this lithograph, of which we estimate that there are between 250 and 300 impressions. Many were sold – this was unquestionably Munch's best selling picture – and some were given away. Nonetheless he made sure to keep a large and varied selection himself, so today the museum has as many as 115 impressions in its collection.

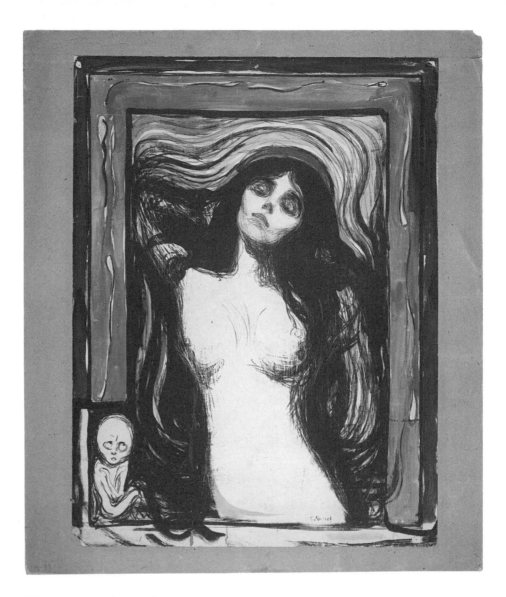

Madonna (1895)
Hand-coloured lithograph
640 × 475 mm

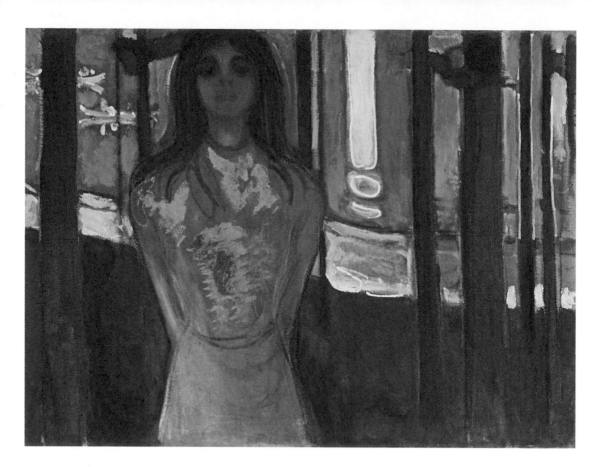

Summer Night. The Voice (1896)
Oil on unprimed canvas
90.5 × 120 cm

A mysterious and alluring female figure stands before us. She is wearing a pale blue dress and is situated in a shaded forest. The dark hollows of the eyes attract our gaze and it is unclear whether the eyes are open or closed. At closer inspection, she seems to be staring right at us. Does she want us to accompany her into the forest?

The shadows that envelop the woman in darkness make her appear to be enclosed in her own world. The clearly delineated column of the moon on the water, the undulating coastline and the two boats are all that light up the picture. The people in the boat seem to be moving, in contrast to the erect woman who stands there like a caryatid. Although she appears withdrawn – rendered by Edvard Munch as a unified shape in which the body, the head and the hair practically merge together – the position of the arms behind the back and the frontal posture create the impression that she is simultaneously flaunting herself or addressing whoever is standing in front of her. She seems to be pushed towards us, leaning slightly forward, almost as though she is bending. Her seductive gaze brings to mind mythical creatures like wood nymphs and sirens, who used their beauty to lure men into the forest. The distinctive white outline of the column of the moon accentuates the vertical lines that are repeated in them, in the water between the tree trunks and even in the female figure. The tall slim trees create a kind of railing between the woman and the landscape beyond. The woman may appear trapped in the dark forest. The impression is claustrophobic. The motif has evidently fascinated Munch, since he created several versions of it. In addition to drawings, he made drypoints and woodcuts in which he demonstrated a desire to experiment. With the help of various techniques and colour schemes, he adapted the motif to new compositions.

There are two painted versions of this motif. The first one was painted in 1893, and exhibited the same year as part of the series Die Liebe (Love). In the other version, which we see here, the woman is drawn forward in the picture plane, closer to the viewer. She thus appears to be seeking contact, and less dreamy. The impression is underscored by a stronger and clearer colour scheme. The palette is colder and less naturalistic. The colours gain a decorative character – such as in the blue, brown and white contours of the tree trunks. The brushstrokes are applied with a light hand, in more rapid and thinner layers than in the first version.

When the Polish author Stanislaw Przybyszewski described the 1893 version, he associated the motif with what he calls "the longing of adolescence". According to him it is a mood that "is born suddenly, grows, swells, expanding formlessly, it rolls here and there, and then folds into itself screaming for form, a uniform shape. And then it may happen that the sky and the earth merge together, and the trees become green telegraph poles, and everything swirls in a vortex, and the blood boils and flows upward to the eyes". Pubertal longing, mythical beauty or seductive female cunning – the figure is impossible to pin down and remains a mystery, and that is alluring in itself.

Representations of woman as a lethal creature, a femme fatale, were popular motifs in the art of the 1890s. In addition to mythical figures there are also countless depictions of Salome with John the Baptist's head on a platter, and Judith holding Holofernes' severed head. Edvard Munch has many references to the theme as well, in his graphic works and drawings. The earliest are a couple of drawings and a drypoint from 1895–96 of a naked woman holding the severed head of a man.

In 1896 Munch made several lithographs that play further on the idea of the painting *Separation*, where the woman turns away from the man, while her hair is blown back and coils around his neck and attaches itself to his heart. He also made a lithograph as a companion piece to this motif, *Attraction*, where the heads of the man and woman are turned towards each other, and her hair softly falls around his neck. This hair symbolism has gained a somewhat more dramatic form in the lithograph and woodcut with the descriptive title *Man's Head in Woman's Hair*. The title probably stems from Gustav Schiefler's catalogue of Munch's graphic works from 1907 – at an exhibition in Oslo in 1901 the woodcut was simply called "The Hair".

The woodcut shows a female head in profile and a man's head in a frontal position, totally engulfed in her hair. In an early, monochrome impression the hair is painted blood red, and in the multi-coloured prints the hair and her face are both printed in red. In these cases Munch has used two woodblocks – one key block where the motif has been carved and one colour block. The key block for the woodcut has the stamp of a Parisian firm on the reverse side, and was almost certainly carved while Munch was still there. All evidence indicates that he worked the woodcut further after he came home to Norway in the spring of 1897, and it may have been then that he conceived the idea of using a colour block that he sawed into four parts. As a boy, Munch was taught to use a fretsaw by a carpenter in the neighbourhood, and he had the equipment he needed at home. This turned out to be an extremely efficient way of creating multi-coloured prints. Each individual piece could be inked with the desired colour, be assembled together again like a puzzle and then printed as if it were a single, complete block. The multi-coloured prints of *Man's Head in Woman's Hair* are printed in black or dark blue-grey from the key block, and red and blue from the colour block. The fact that the man's head is literally cut out, strengthens the impression that it is a severed head.

In autumn 1897, Munch had a large exhibition at Dioramalokalet in Oslo, where he launched a plan to create unique portfolios of his most important graphic works. According to the catalogue, 22 of the exhibited works belonged to such a portfolio, which he called "The Mirror", and as the cover for the portfolio he used the woodcut *Man's Head in Woman's Hair*. For this exhibition, Munch had made a poster for the first time, which he created by transferring the motif of the two heads to a lithographic stone using the frottage technique.

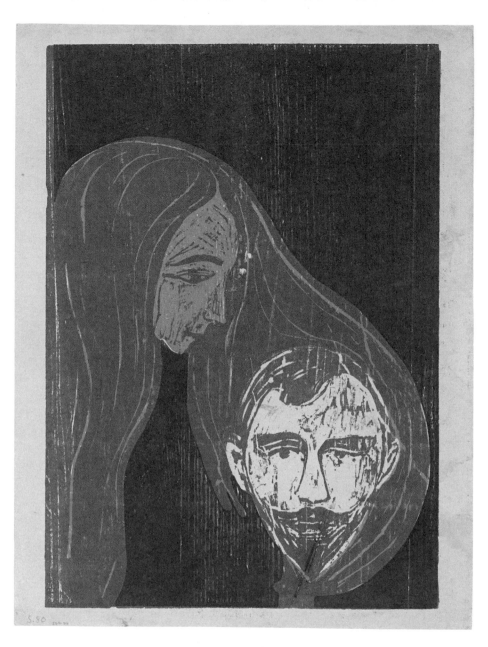

Man's Head in Woman's Hair (1896)
Woodcut printed in colour
588 × 446 mm

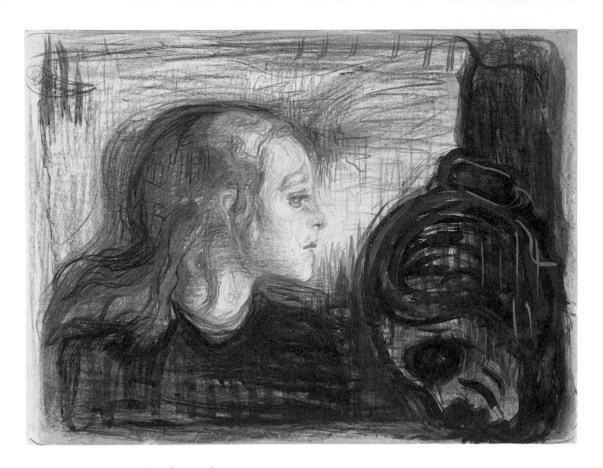

The Sick Child I (1896)
Hand-coloured lithograph printed in colour
432 × 573 mm

The painting *The Sick Child* (Nasjonalmuseet, Oslo) from 1885–86 was Edvard Munch's breakthrough as a pioneering artist. The coarse painting method was met with criticism by many and enthusiasm from a select few, and for Munch personally it became a pivotal motif in his oeuvre. It is not surprising, then, that he started to create graphic versions rather soon, once he began his career as a printmaker a few years later. First among them was the etched version from 1894. Nearly the entire motif is included here, although in a mirror image, as happens when one draws the motif right facing on the plate. What is interesting, however, is the miniature landscape he has added under the motif itself: perhaps an allusion to what the sick girl is gazing at through the window, and pines after. The window which is visible in the painting, but hidden in the etching.

The most well known graphic version of the motif is nevertheless the lithograph. Unlike the painting and drypoint, the lithograph focuses on the girl's head, which is depicted with great sensitivity and empathy. The black and white version we see is executed with lithographic crayon and scraper. This crude scraping on the stone gives the lithograph some of the same textured quality as the first painting.

The many variously coloured impressions of this lithograph say something about how important the motif was to Munch. In lithography, each colour must be printed from a separate stone, and here he has drawn the motif, or parts of the motif, on as many as six stones. Each of them is then applied with different colours and printed in various combinations, with alternating numbers of stones. This results in a large range of colour renditions, with a correspondingly large register of expressions. In many prints, the colour red in different nuances is dominant and creates an impression of the ravages caused by fever. The face remains pallid nevertheless, as a harbinger of what lies ahead.

Consolation is an element in the painting and drypoint, as expressed by the bowed woman who rests her hand on the girl's arm. In the lithograph the sick child is alone, but in a few impressions Munch has painted in the older woman's face after the lithograph was printed. The skull-shaped head might not bring much solace, but it creates a human relationship in the picture just the same.

Edvard Munch met the 14-year-older Swedish author August Strindberg shortly after the closing of his "scandalous exhibition" in Berlin in the autumn of 1892. By that time Strindberg was already a famous writer, of the same stature as Henrik Ibsen. Munch immediately painted a portrait of Strindberg. In Berlin, together with other Scandinavian and German artists and writers, they frequented a small tavern called "The Black Piglet".

When they met again three years later in Paris, Munch was working feverishly with printmaking in multiple techniques. In the summer of 1896 he portrayed August Strindberg again, this time in a lithograph in black and white. Here Strindberg's face is seen slightly from the side. His shirt collar, throat and head, with the bushy head of hair (which he was proud of!), fill a large portion of the picture plane. The gaze is meditative, introverted, and perhaps slightly apprehensive. Around the portrait Munch has drawn a frame with geometrical and wavy patterns. In the waves to the right he has drawn a naked female figure. At the bottom he has misspelled the author's name: A. STINDBERG. Art historians have asked themselves whether it was intentional, or simply an oversight. To draw and, even more so, to write on a lithographic stone requires concentration, simply because one has to write backwards. Only in this way does the text become readable in the finished print. Strindberg was not satisfied with the result when he saw it, and cried out, "Why have You placed a Woman as a framework around my picture?". "I have to earn money", Munch responded. The spelling mistake was perhaps Munch's way of playing a trick on Strindberg, a form of sweet revenge. One day when they were strolling down the street in Berlin, Strindberg had suddenly placed his foot in front of Munch's so that he tripped and fell. "Hooligan", shouted Munch angrily. Strindberg replied that he had learned the sport from a Norwegian.

In Paris, Strindberg was indisposed, anxious and paranoid. He was living alone while conducting extremely flammable chemical experiments in an attempt to make gold! On a postcard to Munch he wrote: "The last time I saw you, you looked like a murderer. Or at least like a henchman". They soon became good friends again and later collaborated on a joint project for the German periodical *Quickborn*. In a later version of the portrait Munch removed the woman in the frame and corrected the spelling mistake, most likely to placate Strindberg. Another version is without either the name or the frame. Here Strindberg stands out more clearly and unfettered against the dark background. There are, in other words, three versions of this portrait. Many years later, in 1909, Munch told his friend and helper Ludvig Ravensberg that the version containing the woman in the frame had sold very well. Now he only had a few prints left.

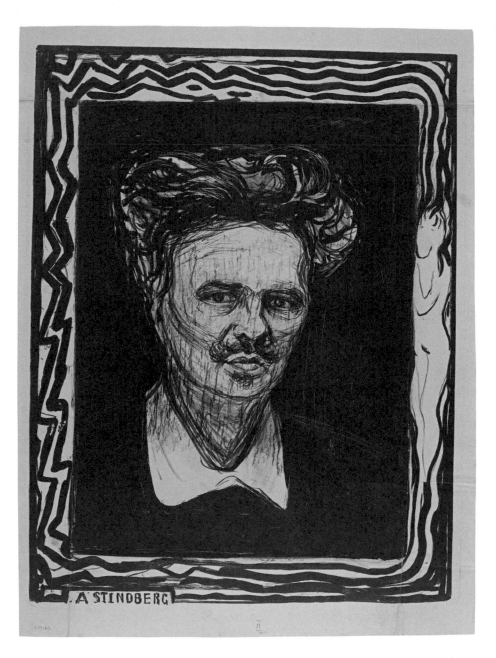

August Strindberg (1896)
Lithograph
612 × 462 mm

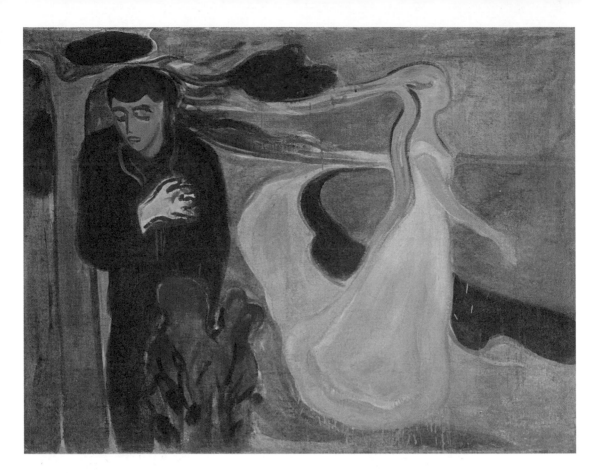

Separation (1896)
Oil on canvas
97.5 × 128.5 cm

In art, the artist has the liberty to portray a world that distinguishes itself visually from the world we live in. The laws of nature we humans are subject to can be disregarded on the two-dimensional picture plane. The world Edvard Munch depicts on canvas is not necessarily identical to the world as we know it. In this sense Munch is not a realistic painter. In 1889 he writes:

> We desire something else than a mere photograph of nature.
> Nor is it [our intention] to paint pretty pictures to hang on a sitting room wall.
> We seek to find out if we cannot, if we cannot succeed ourselves[,] then at least
> lay the groundwork for an art that can be bequeathed to mankind. An art that
> seizes and grabs hold. An art that is created with one's lifeblood.

In the painting *Separation* we see several phenomena that break with our perception of reality. The painting is a depiction of a man and a woman. The woman is facing right, away from the man. She has long blonde hair. The hair falls down her back, but a lock of hair stretches horizontally towards the man. It coils around the man's neck and downward towards his right hand, which rests on his chest. Munch presumably doesn't want to tell us that there is a wind blowing on the beach, and that the hair is fluttering in the wind. On the contrary, the artist is illustrating a feeling, depicting an emotional bond between the man and the woman. If we look at the outline of the man's hand, it is painted in a blood-red colour, as though he is bleeding from the heart. We humans know that a man who is bleeding from the heart cannot stand upright for very long. Nevertheless, the man in *Separation* remains standing.

The title of the painting is *Separation*, but it is not the physical separation or distance between the two that Munch illustrates here. His theme is the emotional separation that occurs when two lovers each go their own way. The painting is a depiction of the pain that arises when feelings are torn out of the heart and create emotional scars – large and serious as though the heart is bleeding out through the chest.

Below the man's red hand, Munch has painted a red bush. The man's heart bleeds onto the plant, turning it blood red. Munch has used this image in several motifs, among others in *Blossom of Pain*, where we see a man growing up from the earth. Alongside him a plant also grows. The man holds his hand over the left side of his chest. The blood nevertheless flows from it, descending to the earth and continuing to flow towards the plant, giving it nutrition. The plant can be interpreted as a symbol of creativity and innovative work. In both *Blossom of Pain* and *Separation* it is possible to interpret the plant as new growth that emerges from emotional pain and heartache, giving birth to new art.

This painting is signed and dated, but the indistinctly painted year has been read as both 92 and 97. It has previously often been dated 1892, but in recent years it has been viewed in connection with Edvard Munch's further development of the motif in woodcuts in 1897, and dated accordingly. The dating nevertheless remains uncertain, and in the exhibition catalogue published on the occasion of the 150th anniversary of Munch's birth, in 2013, it was dated as "probably 1893". There are three versions of a couple kissing from 1891–92, each placed in different positions in relation to the window, and the many versions make it difficult to identify which one was included in the early exhibition catalogues. One of them was undoubtedly included in the series entitled Die Liebe (Love), which was shown for the first time at Munch's exhibition in Berlin in December 1893. This series was the beginning of his many presentations of what would eventually become known as The Frieze of Life. When the series was presented in its full scope for the first time at the Berlin Secession in 1902, *The Kiss* was included as a central motif, and it was the present painting that was shown. The same applies to all later presentations of The Frieze of Life.

Munch's friend, the Polish writer Stanislaw Przybyszewski, described the painting from the exhibition in 1893 in his book *Das Werk des Edvard Munch* (The Work of Edvard Munch), and perceived the fusion of man and woman as an image of the all-consuming sexual drive. The faces have fused together into one large stain in which all individual features have been erased. In a review of Munch's exhibition at Bing in Paris in 1896, August Strindberg interpreted the version of the painting that was shown there in similar terms. Strindberg emphasised in particular the self-effacing element, whereby the battle of the sexes caused the man to lose his individuality.

Both these writers had strong opinions about the power that women yielded over men, and when Munch's pictures were often interpreted in a misogynist light, it is more likely their perceptions that are revealed than Munch's. If one looks at his many versions of the kissing couple without the spectacles of time, it is just as reasonable to view the motif as a striking and clear image of the devotion and love between man and woman.

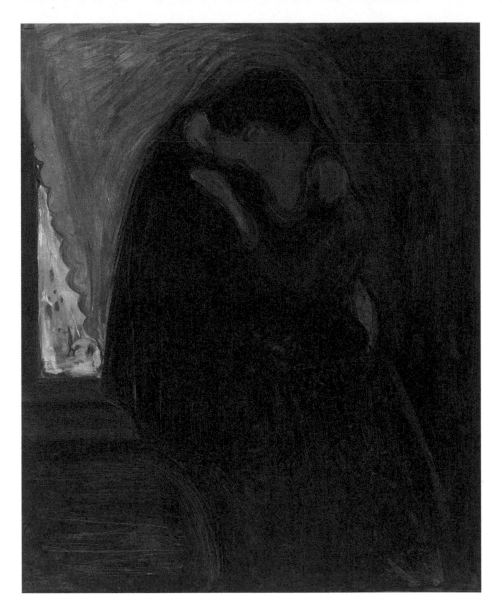

The Kiss (1897)
Oil on canvas
100 × 81.5 cm

Towards the Forest I (1897)
Woodcut
498 × 562 mm

The two figures stand there at the centre of the picture like a human Yin Yang symbol. The two fundamental forces that together form nature's cycle of life and bring balance to existence. Without one of them, the other is nothing, together they are everything. Youthful, sensual love is the central focus of this woodcut. Yet Edvard Munch called the picture Towards the Forest. Not "Lovers" or "Man and Woman in Front of a Forest". "To explain a picture is impossible", wrote Munch. "It is precisely because one cannot explain it in any other way that it has been painted. One can only give a little hint of what one was aiming at". In this woodcut he points to the forest, and even the movement towards and into the forest, as essential. They are on their way into it. In there they can forget themselves, find each other, and hide from the world. But it is not without peril.

In fairy tales and myths the forest is an archetypal element; impenetrable, frightening and alluring. Apollo, the god of rational thinking, does not live here. This is Dionysus' realm, the god of fertility, ecstasy and irrational forces. In there lurk dangers and trials that must be confronted and overcome on one's path towards maturity and meaning. It is "an area where desire and doom are equated", as Karl Ove Knausgård writes about another of Munch's forest motifs, *Summer Night. The Voice*.

There are many kinds of forests: monumental, open pine forests and birch woods with white trunks like vertical columns of light. But this forest is something else. Against an ominous red sky it stands there like a wall, like a curtain, simultaneously totally flat and endlessly deep. And the two figures in the foreground are already permeated by the forest's atmosphere. They have become one with their own yearning, their own desire. Engulfed by each other, and soon to be swallowed by the forest.

And after that? Will the flame of love continue to burn undiminished? Or will it turn to *Ashes*?

Metabolism is a strikingly monumental work: A naked woman and man stand facing each other on either side of a tree trunk in a dark forest. Is it a shoreline, ocean and sky we glimpse in between the trees in the background? A wide frame is equipped with carved reliefs; the upper border depicts the elongated silhouette of a town, and along the lower border large roots seem to be sucking sustenance from a human cranium and an animal skull. The title *Metabolism* is a scientific term for chemical and biological processes linked to the perpetual cycle of life, comprised of death, decomposition and new life.

The picture was shown for the first time in the spring of 1900, under the title "Adam and Eve". This biblical reference is found in several of Edvard Munch's motifs, such as *Ashes* and *Jealousy*. The Bible relates the story of the very first human couple and original sin; in our picture there is no apple, nor a serpent that tempts Eve. The monumental picture resembles an altarpiece, although it should not be called a Christian motif for that reason. There are indications that the painting was intended to complete The Frieze of Life motifs that Munch painted during the 1890s. It integrates central themes of the frieze, and was called "Life and Death" at the large Frieze of Life exhibition in Berlin in 1902. The silhouette of a town may perhaps hint at a metaphysical dimension – with forerunners in graphic works from 1897. Interpreted in a Christian perspective, the town would be a reference to The Heavenly Jerusalem. In texts and titles Munch uses the term "The Land of Crystals".

In 1903 photographs were taken when the large Frieze of Life exhibition was shown in Leipzig. There we find our picture high up on one of the end walls, situated very much like an altar picture in a church. We also notice that the composition is not identical to what we see today. Between the two figures there is no tree trunk, but a flourishing plant – which we know was red – and out of the plant a little human embryo comes into view. In other words the motif was originally less realistic and more symbolistic, a genuine *Gedankenmalerei* (a thought painting), as the Germans say.

Subsequently it was the decorative and brightly coloured – and more "French" – *The Dance of Life* that gained the status as The Frieze of Life's major motif. Yet Munch continued to claim that *Metabolism* was essential to the frieze: "... necessary for the entire frieze as a buckle is for the belt". He also writes that the motif functions as a link or intermediary between The Frieze of Life's intimate universe and the "great, eternal forces" of the University's Aula decorations.

The motif was thus painted over and "modernised" – "Adam and Eve" became *Metabolism* – most likely in 1914. In the catalogue for an exhibition in 1918 the picture is reproduced in its new state and with a simple frame. After Munch's death in 1944 the carved parts of the frame were found in the cellar under the winter studio at Ekely and dutifully registered, but it wasn't until some time in the early 1970s that the picture was reunited with its original frame. It is still possible to see traces of the over-painted plant and glimpse the contours of the little embryo.

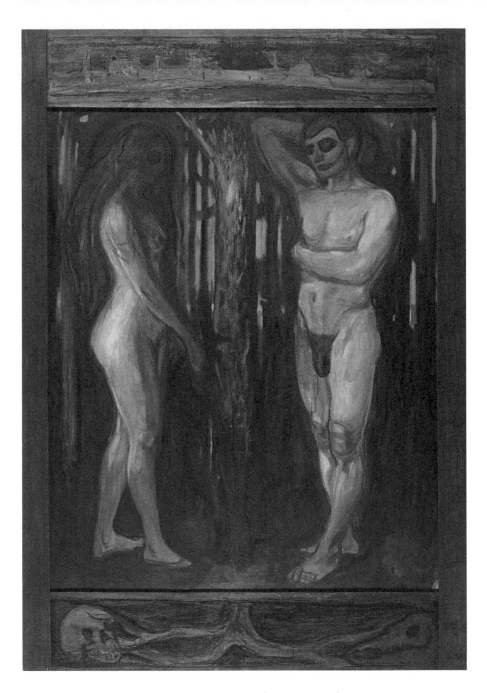

Metabolism. Life and Death (1898–99)
Oil on canvas
175 × 143 cm

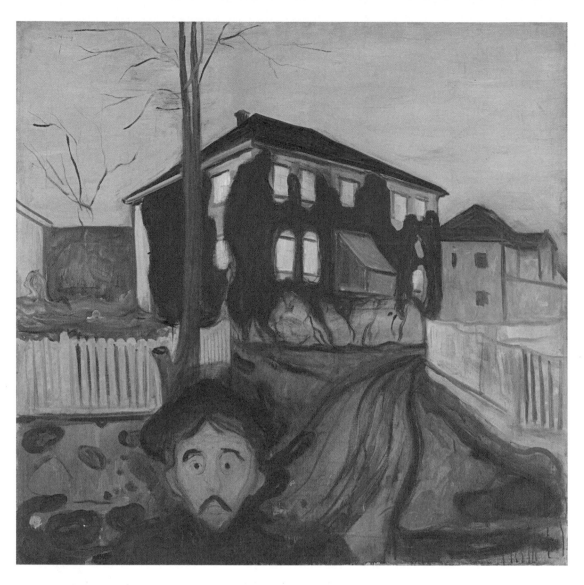

Red Virginia Creeper (1898–1900)
Oil on canvas
120 × 121.5 cm

The central element in the painting *Red Virginia Creeper* is the house with many windows and red Virginia Creeper that covers almost the entire surface of the building. The roots that stick out of the ground and the bright foliage bring to mind a house engulfed in flames. Seen in light of such an interpretation, we can perceive the figure in the foreground as someone fleeing from some catastrophe that has just occurred back there. The symbolically laden elements used in *The Scream* and other works from the mid-1890s, are conspicuous here as well: the wide-open, terrified expression of the eyes, the cold green complexion of the face, the billowing lines. The undulating shape leading from the house down to the figure is reminiscent of a cascading river and drags the figure with it. The person will soon disappear out of the picture frame. Edvard Munch seems to be using a film trick to create movement, and he has depicted fleeing or approaching figures in a similar way in other works.

The windows of the house are lit like glaring eyes with a cold, blue, dismissive light. The leafless tree nearly grows up out of the figure's head, and has a severed branch. The white picket fence both closes and opens the connection to the house. All of these elements contribute to creating a symbolically grave undertone.

What is it that lies behind this disturbing atmosphere? Can the picture be interpreted in view of Munch's disturbed emotional life during this period? The house resembles the Kiøsterud manor, a well-known building included in a number of Munch's motifs from Åsgårdstrand. The house stands there, monumental and immobile. We notice that leaves have fallen from the trees, and the autumn colour of the creeper is an indication that summer is over. A cool sky hangs above the houses, winter is on its way. It's as though the cold has grabbed hold of the figure as he hurries away from the flaming house with the cold windows. Something seems to have gone terribly wrong back there, something he must flee from in a hurry. The trouble is given painterly expression in a partly abstract and partly figurative mode of expression.

Escape caused by inner turmoil always feels like compulsion. This type of escape is never planned; a desperate urge to get away, in order to hide, arises suddenly. It is therefore also a solitary experience and often unbearable. Munch's approach of only showing the head of the fleeing figure draws our attention to the expression of fear on the face.

This woodcut is a classic Munch motif, with many of the elements the artist employs when he depicts the vagaries of love between humans. Neither the man nor the woman is facing the viewer, but they are not facing each other either. By this means Edvard Munch creates an introverted atmosphere. The woman's attention is directed at the ocean and the reflection of the moon on the ocean's surface. The man's gaze, on the other hand, seems to be directed at the woman, sharply delineated with her red-orange hair. Is it a rejection we are witness to? The dissimilarities and distance between the two are underscored by their attire. The woman is dressed in white, the man in black. The motif is built up of contrasts of this type: woman against man, water against land and black against white.

Although this motif also exists as a painting, it is as a woodcut that it finds its true form, with its simple beauty and melancholy depiction of loneliness. In the museum's collection there are 47 impressions in different variations. And numerous impressions, which are privately owned and in other museums, are proof of the motif's popularity.

As a woodcut, the motif exists in a range from very simple prints in pale blue, black and white, to more complex and colourful impressions, such as this one. The woodblock was later reworked, and the shoreline gained additional details. Munch has used stencils to add the moon and its reflection in the water. These are elements that are not found in all the prints.

This particular print is used as a typical example of Munch's innovative approach to the woodcut as technique. With the help of a fretsaw, he cut out various sections of the woodblock. The woman is a good example of this. She can be lifted out of the block as if she were a piece of a puzzle. This is the reason behind the name given to Munch's technique – the jigsaw puzzle technique. Traditionally, a new block was used for each colour in the woodcut. To saw out parts of the block allowed him to more easily colour the separate elements of the same block, but it also left a white contour around the parts that had been cut out. These white lines can contribute to merging the elements in the picture together, but here they accentuate the distance instead, isolating the figures from one another.

Some might argue that the couple in the picture appears precisely like that, as stiff pieces, and are not credible representations of human beings. This is presumably a conscious point on the part of the artist. He allows the technique to corroborate the theme of the motif. Munch was preoccupied with the driving forces of human nature, such as attraction and desire. The column of the moon in the water has sometimes been interpreted as a phallus – an image of Eros. Perhaps it is neither the woman nor the man who actively animates this scene. They are both marionettes in the bright summer night that plays its games with the unsuspecting humans.

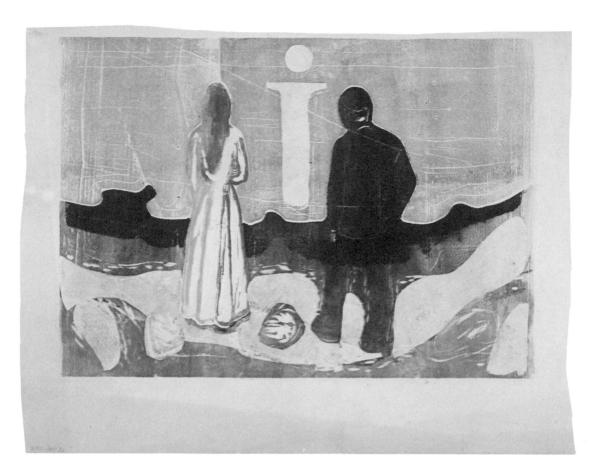

Two Human Beings. The Lonely Ones (1899)
Woodcut printed in colour
396 × 552 mm

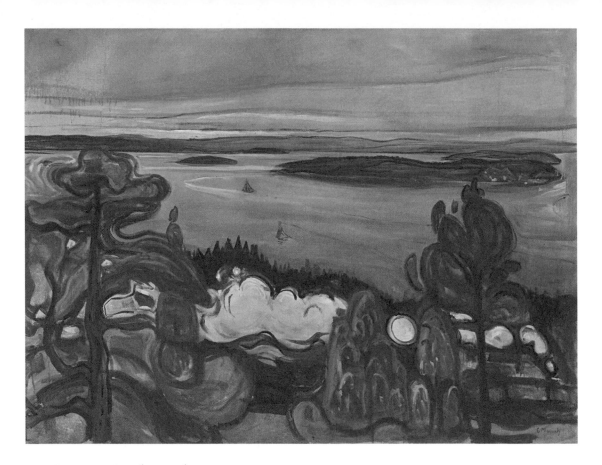

Train Smoke (1900)
Oil on canvas
84 × 110 cm

Train Smoke is both an expression of movement, and static. We can barely see the train. Only the locomotive is visible. The rest is hidden behind the thick, white smoke that hangs in the air like a furry tail stretching through the landscape. Edvard Munch has painted the view from a boarding house on the outskirts of the capital. In front of us, the landscape descends steeply towards a railway line, where a train is passing on its way out of the picture. In the background the landscape opens onto the Oslo Fjord, with its islands and the reflected violet shades of the clouds. Although the scene is held firmly in a taut composition, the wavy lines of both the landscape and the smoke contribute to giving the motif an impression of movement. The effect of the locomotive's speed has the same effect: the smoke that hangs behind in the air, and that will continue to increase. We see traces of movement that will almost imperceptibly dissolve and disappear.

When Munch painted *Train Smoke* he had recently been criticised for being a literary painter, who did not place enough significance on purely painterly qualities. Prior to the turn of the century, he had leaned increasingly towards enigmatic motifs that were intended to give symbolic expression to the obscure compulsions of human nature. Munch's depictions of the dark corners of the mind were incomprehensible to many. In addition, the art of painting was in a process of transition at the time. The creator of *The Scream* and *Madonna* was becoming outdated. Around this time the German critic Julius Meier-Graefe wrote a pejorative review in which Munch's symbolically laden art was criticised. He compared Munch to Van Gogh, and Munch did not come out the winner. Meier-Graefe pointed out that Van Gogh was first and foremost a painter, while Munch's pictures were characterised as thoughts. They were too introverted and too strongly marked by his psychological insights.

Munch had a stubborn character, but it appears that he took this criticism seriously. With *Train Smoke* and other motifs from around the turn of the century, he turns his gaze outward. Pictures such as *Fertility* (1899–1900), *The Girls on the Bridge* and *Train Smoke* have remained standing as masterpieces. We find ourselves at the crossroads between the visible and the imagined. There is little in these three motifs that appears incidental. But it is primarily the impression of the outer world Munch has focused on. Even so, has he managed to sneak a certain Symbolism into these pictures? His motifs are open to different interpretations, so that we can easily insert our own ideas into them. Is *Train Smoke* a meditation on the transitory nature of smoke, which slowly disintegrates – a reflection on the moment in time that the artist wishes to pin down? The title *Train Smoke* may be too leading for what we see. In Munch's time the painting was also called "Towards the Fjord" and "Alongside the Fjord". The first of these older titles emphasises how the landscape opens up from the trees close at hand to the distant view. The second seems to highlight the train's forward momentum along the fjord.

Tightly wrapped up, positioned in a warm and bright location, fed and looked after – the conditions are right for life to thrive. And while the plant does what is expected, namely grow and blossom, there is something seriously wrong with the young woman. Although apparently physically healthy, like the plant, she lacks any sign of human awareness. Her hands are half-closed, the mouth shut, the eyes unfocused and staring blankly into space – every pore of her body radiates absolute passivity. Seated in a corner, she shows no interest in the outside world visible through the window or in the plant in front of her, let alone in herself. Her body may be present but her mind is somewhere else. We cannot join her, wherever she is. Instead, we are left with a sad feeling of loneliness.

Traditionally, a room is associated with shelter and safety. Edvard Munch often challenges this notion by experimenting with a room's spatial properties, thus giving it a psychological dimension which expresses the inhabitants' emotional states ranging from insecurity, angst and fear to loneliness. Good examples are his paintings *Puberty, Death in the Sickroom, "Zum Süssen Mädel"* and this work.

This room is closed. It has no door, just one window which reveals a winter landscape. The window offers no invitation to cross into the outside world. On the contrary, the framed panes, which are doubled-up by their shadow image on the adjacent wall, look like prison bars. Curious patterns, such as the floral wallpaper and the flame wood table, stand in lively contrast to the otherwise austere room. Most intriguing, however, are the two vertical lines behind the woman. While the line on the right defines the corner of the room, the other line has no clear function and thus invites other readings. It literally emerges from the top centre of the woman's head, creating allusions to a puppet on a string. Though it is unclear who is holding the string, the power is clearly located outside the described room. The woman has no control over her state of mind.

Munch had first-hand experience of "melancholia", a term which around 1900 was generally applied to major depression. He knew that this condition, which defies the standard rules of social life and communication, can be trying to all those involved. In 1929 he recalled the making of this painting and that he had wanted to record the monumental aspect of the sitter's "dark mute eternal sorrow", where the real world was of total insignificance. Munch's text includes a short reflection on the relativity of life, which seems to sum up the difficult situation:

> – *What is greatness? – Infinitesimal compared to the stars*
> – *What is smallness?*
> *Great compared to its atoms – which are constellations*

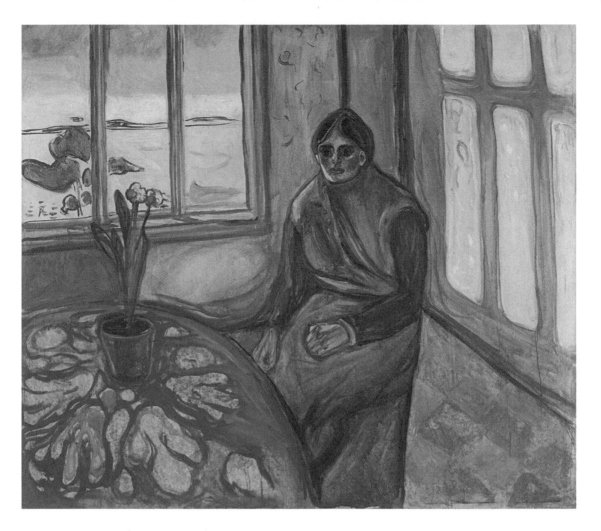

Melancholy (1900–01)
Oil on canvas
110.5 × 126 cm

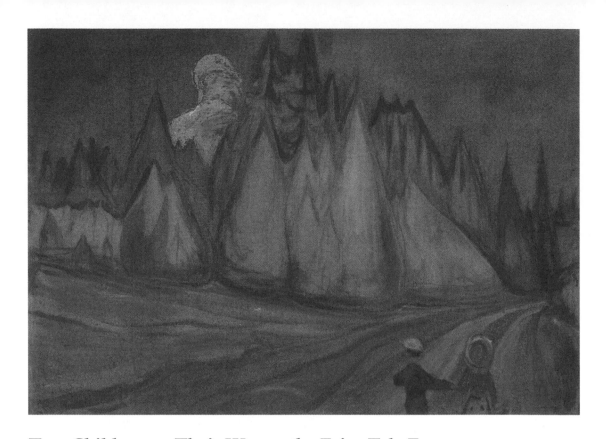

Two Children on Their Way to the Fairy Tale Forest
(1901–02)
Casein and oil on unprimed canvas
84 × 121 cm

A few years after creating the woodcut *Towards the Forest I*, where two lovers stand before a mysterious forest, Edvard Munch paints what might appear as a childlike version of the same motif: two children – hand in hand – on their way towards the forest. But this forest is an enchanted forest, so they shouldn't be in any danger, right? Well, as everyone knows – not least children – fairy tales may also conceal grim adventures and frightening creatures. And what is it about that strange cloud behind the treetops? The sky is quite murky and the trees have dark contours. It must be dusk rather than the middle of the day. Just the same, the two little ones are approaching the unknown alone. Once again, it is the mysterious forest exercising its alluring power.

We can see that this is a pine forest. Yet it's as though we see it through the eyes of the children. The forms are hastily drawn – so simplified that none of the trees individually look like a pine tree, yet together they form a pine forest. But they also become towers and turrets in a fairy tale castle, for anyone who wishes to see it. And isn't that a cathedral far into the distance, where the road ends? There is a strong gravitational pull in this nature. But its effect is not a downward pull from above; it pulls inward, to the point where all the lines come together. We cannot see whether the children are standing or walking, but we know that that is where they are headed.

It is not the first time Munch depicts two children holding hands. We also find them in a drawing from 1889–90, which he has given the title *Berta and Karleman*. These are names he used to refer to his sister Sophie and himself in some of his writings, in particular in connection with his mother's death. And there is an unmistakable atmosphere of abandonment surrounding the children in the barren and uninviting landscape. But they have each other, just as the children on their way to the fairy tale forest have each other. The similarity in the depiction of the children is striking, and it is reasonable to think that there is a line that can be traced back to Munch's childhood in this painting as well.

In the years following the turn of the century there are many depictions of children in Munch's art, often associated with Åsgårdstrand (*The Girls on the Bridge, Four Girls in Åsgårdstrand*). In 1901–02 he painted two other pictures of the fairy tale forest motif as well: *Children in the Forest* and *The Fairy Tale Forest*. In both of these, however, a whole flock of children is out walking. In the latter picture the colour tones are much brighter and more colourful, and the atmosphere is consequently more carefree and cheerful.

All things considered, *Two Children on Their Way to the Fairy Tale Forest* is not predominantly a gloomy picture. There is something about it that vibrates, a mixture of the mundane and fairy tales, anticipation and apprehension. Yet the children project an air of friendship and affection, and perhaps the unsettling aspect of the picture is not primarily due to the ominous cloud or the forest's mysterious secrets, but to the unknown and uncertain adventure that lies ahead of them. Life itself.

Edvard Munch made a total of four woodcuts of this motif, based on earlier paintings. He probably carved the first version before he left Paris in 1897, and during the following years in Norway he continued working on two new designs. In two of the versions, the man and woman are enclosed in powerful aura lines, but quite early in the process he must have cut the figures out with a fretsaw, so that he might also print them with varying woodblocks as a background. What is typical of these background blocks is that the grain and knots of the wood play a crucial role in the final result.

Towards the end of 1901, Munch decided to make a go of it again in Berlin, and had a great number of his available works shipped there. Among them were woodblocks that he hoped to be able to print new impressions of – and sell many of. But by mistake the crate with woodblocks was sent to Åsgårdstrand instead of Berlin, and Munch believed for a long time that the blocks had been lost forever. At the beginning of 1902 he therefore carved new blocks for *Moonlight*, *Melancholy* and *The Kiss*. The original blocks later reappeared, and this made it possible for him to combine old and new blocks.

A large number of impressions of the new version of *The Kiss* were printed by Lassally in Berlin, from 1902 and until the outbreak of WWI in 1914. The present work was probably printed in 1913, at a point when Lassally printed many of Munch's lithographs and woodcuts on thick, white paper. After Munch brought the woodblocks home from Berlin, he continued to print many impressions in Norway.

This last and final version of the woodcut has gained an extremely simplified form, in which the colour block's vertical lines and characteristic knots create a decorative background for the kissing couple. In its striking simplicity, the picture resembles a modern pictogram. Amazing that it can be done so simply and affectingly!

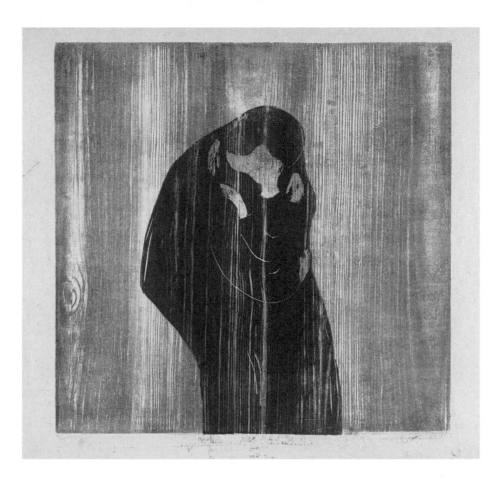

The Kiss IV (1902)
Woodcut
468 × 468 mm

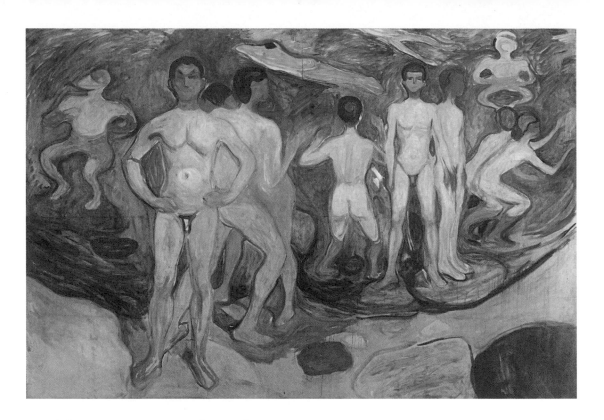

Bathing Young Men (1904)
Oil on canvas
194 × 294 cm

Munch spent the summer of 1904 in Åsgårdstrand, painting murals on canvas for the nursery in the home of Max and Marie Linde in Lübeck and preparing for a major exhibition in Kristiania. During this busy time, he organised a kind of "health farm" for some of his close friends: their mornings consisted of boxing, swimming, and sunbathing and their diet consisted of salad and lightly cooked foods. The artist recounted that he used these friends as models for *Bathing Young Men*, and that the painting's ambitions engaged the vital energies of his little summer community: Munch describes "a huge canvas ready to be populated by the strong men wandering among the waters [...] Here we swim, box, and throw rocks in order to develop bigger muscles."

In the painting, nearly life-sized men are pictured standing in pairs or clusters on the shore; others are poised to enter into or are immersed in water. Two of the figures, facing us directly, are clearly defined, while the others overlap in such a way that it is hard to determine one's flesh from another. The representation of seaside athletics, in which males wrestle, splash, dive and swim, is also eroticised through the placement of one figure's hand on another's thigh.

The scene, painted in vivid spectral colors, is full of doubling: The bodies of all of the naked males are in some way partitioned, either because their deeply bronzed heads and hands are distinct from their otherwise pale flesh or because the water has divided them into zones of pink and green-blue. The youths who stand on land are clearly human, but those in the water seem to devolve into amphibians. Most dramatically, the artist painted the scene using a double perspective. The figures on the shore are painted head-on. The expanse of horizonless water, however, is viewed from above, tilting upward to become parallel to the picture plane, suffusing the scene with intimate isolation.

Munch had made paintings of bathing figures since the 1890s, but this monumental scale was new. Its theme of male athletics and eroticism by the water's edge, like Munch's informal health colony, allies it with Vitalism, a philosophical and artistic movement particularly prevalent in Northern Europe around 1900. Vitalism proposed the regeneration of a vital force through the cultivation of the body in nature, negating the supposedly stultifying effects of urban modernity. Sunbathing, swimming, and open-air athletics were among the activities that were understood to reform the body and emancipate instinct.

A naked red-haired upright body occupies centre stage, a shadow behind it. One of her eyes looks upwards, the other, smaller one, forwards. Thick bits of yellow make or unmake her face. Her hands droop, inactive. Her spectacular act brings in a temporal aspect. The deed has been done; what we see is the enduring consequence. Dead is forever. The man's oblique foreshortened compact body forms a triangle with her upright body. The careful cropping does not touch his body; enough to show the act of framing yet leaving the Christ-like body respectfully intact. His arms are spread. A thin line of blood seeping out of his heart is not connected to the large bloodstain to the right of his thigh, and the enormous bloodstain on the lower right of the bed has no connection to anything. This blood looks like fresh meat, as if his heart has been ripped out rather than pierced. Colours connect the round plane, apparently a table, to the woman's legs that we see through the table's edge. The woman gets most of the light, the man is in the shade although he is clearly visible.

The man's spread arms hint at the iconography of crucifixion scenes. The merging of the left edge of the table with the woman's legs makes her seem transparent, ghostlike. Her nudity and the size of the bed hint at a scene of love-making prior to the assassination. This reinforces the temporality and the treachery of the female figure. And once we notice this time element, the plate of fruit on the table and the shapes next to it suggest a meal was being prepared, changing the act of feeding from a symbol into an everyday event, and the narrative into one of deception: she is not going to feed but kill him.

These elements set us on a narrativising course which risks trapping us in with symbolic interpretations before really seeing the artwork. Instead, consider the colour fields of the green wall on the right, moving to purple on the left, both dotted with red flowers indicating wallpaper. The wavy thin green lines, continuous between the wall and the bed, half-cover the white of the sheet so that not much is left of a "depth of field". The woman's ghostly legs thus also allude to the tension between figuration and abstraction which, for such an easy-to-narrativise work, becomes quite intense. This makes an enigma out of the triangle formed by the two hands. They touch, in a gesture we could find touching, if we consider the picture as flat. If we stay with the spatial effect, the hands do not touch as the woman is standing in front of the dead man. The appeal to the spectators to adopt a viewing attitude that allows seeing the image both as flat and spatial, activates them: as a viewer, you decide how to see the painting.

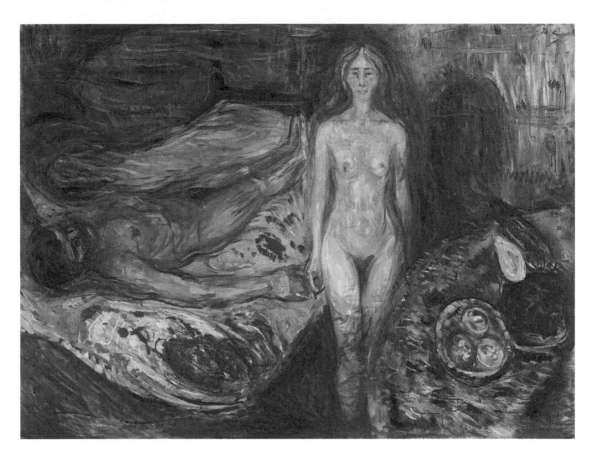

The Death of Marat (1907)
Oil on canvas
150 × 200 cm

Edvard Munch and Rosa Meissner
in Warnemünde (1907)
Collodion print out paper
87 × 87 mm

Edvard Munch was never a serious, exhibiting photographer. Yet, as an amateur who favored small, hand-held cameras, he pursued photography as an experimental medium with himself as his primary experimental subject. His photographs repeatedly include unexpected areas of blank or undefined form and shadows that replace living bodies, extending his iconoclastic approach to form and materials in his paintings and graphic works. His self-portrait photographs are often out of focus as he moved during the camera's exposure time. He appears in some as a shadow or a fragment at the edge of his frame.

Munch's photographs have been dated to two periods, 1902 to 1910 and 1927 to the mid-1930s. In February 1902, Munch purchased his first camera in Berlin, likely a Kodak Bulls-Eye No. 2, a popular amateur's model. Because the camera used light-proof film cartridges and had a small window indicating the exposure number, Kodak advertised this model as "Easy Photography." Eastman Kodak also marketed a small, portable home development system, enabling the amateur to print her or his own pictures. Munch likely made his own contact prints in the 1902–10 period, using such a Kodak kit. His prints are eccentric, demonstrating a curiosity about the photographic printing process itself. As a corollary to his work in lithography and woodcut, Munch explored and exploited the effects of flipping his negatives and double exposures. *Edvard Munch and Rosa Meissner in Warnemünde* is such an image. It pictures the artist and his model standing on the beach in that north German coastal town. Meissner had traveled from Berlin to model for Munch the summer of 1907, her efforts resulting in, among others, the motif *Weeping Woman*. Occupying the foreground of the doubled print, Meissner and Munch are difficult to discern in their overlapping transparency and duplicated placement on the sand. Such doubling transforms the informal souvenir-like beach scene into the arena of an experimental composition: The figures seem to be in motion, an effect that resembles chronophotography, the discipline of picturing a body's successive motions on a single photograph. To further explore the dynamics of composition, Munch flipped and printed the negative, creating a mirror image. His fingerprint was impressed into the emulsion of the negative during the printing process, appearing in both prints.

The Kodak instruction manuals of the period warned the photograhers' subjects to remain still while the camera's shutter was open. However, in his photographic self-portraiture, Munch repeatedly displaced his body during time exposures, interrupting the focus or appearing as a transparency or even a smear. This ghosted or transparent effect in *Self-Portrait in Front of Paintings at Am Strom 53, Warnemünde* demonstrates Munch's exploratory use of the camera to assert photography as a form of expression as much as documentation. The artist's act of striding from left to right is registered by the clarity of his paintings that appear through his partially transparent body.

Jealousy is an intense emotion, often associated with negative thoughts, an experience of uncertainty and fear of loss. It is especially in connection with love and desire that jealousy surfaces. The feeling can arouse anger, disgust and sorrow.

Edvard Munch's great life-long project was the picture series called The Frieze of Life. This cyclical series has many layers, but one of its major themes is love, as it runs its course from infatuation to dissolution and decline. In the series jealousy is also touched upon – a motif we find in several versions. The motifs may be set in a garden, in the bath or, as here, in an undefined space. Some of the 11 painted *Jealousy* variations may appear to be quite similar. What the motifs have in common is that they always depict three persons, two men and a woman. One of the men is often placed up close in the foreground, with his gaze directed straight at the viewer. Visible in the background is a couple consisting of a man and a woman.

In this *Jealousy* motif the woman in the background is placed with her hands raised behind her head, like a seductress. This is a rather common posture for (nude) women in the paintings of modern artists such as Paul Cezanne, Pablo Picasso and Henri Matisse – and Munch. The women are depicted as sexually assertive, and the posture invites viewers to allow their gaze to glide undeterred over the body and its female attributes.

The picture was presumably painted in 1907. That year Munch painted two additional *Jealousy* motifs as well. In these the figures are surrounded by three walls covered in green wallpaper, which we can also glimpse behind the woman in our *Jealousy* picture. In Munch's oeuvre, green is often associated with challenging situations such as illness, death – and jealousy. He not only used the colour deliberately on walls, but also on faces and women's clothing. The faces of both men have a nauseating green hue. Perhaps this is the colour of jealousy, as Munch suggests. The woman, in contrast, is quite red in the face. In Munch's works red is often an indication that the individuals are agitated or stirred by strong emotions.

In the painting *Woman. Sphinx* the woman on the left is wearing a white dress and has blonde hair. Young and flawless, she gazes out across the ocean. The woman in the middle has red hair, and is depicted in a seductive pose. She appears to be sexually experienced and liberated. If we take a closer look at the female figure in the *Jealousy* motif, she seems to be a more complex female type – a combination of the two women in *Woman. Sphinx*. She is wearing a white dress, a common symbol of purity and innocence. At the same time she is depicted in a seductive pose with a flushed red face. Is she a sexually assertive woman wearing a mask of innocence? Or is she a modern woman who is openly signalling her sexual desires?

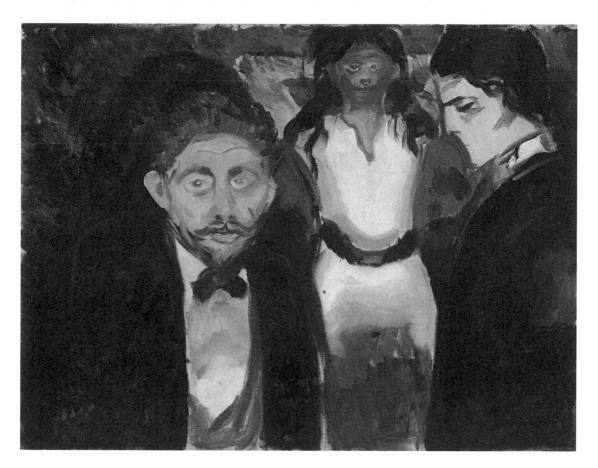

Jealousy (1907?)
Oil on canvas
75.5 × 98 cm

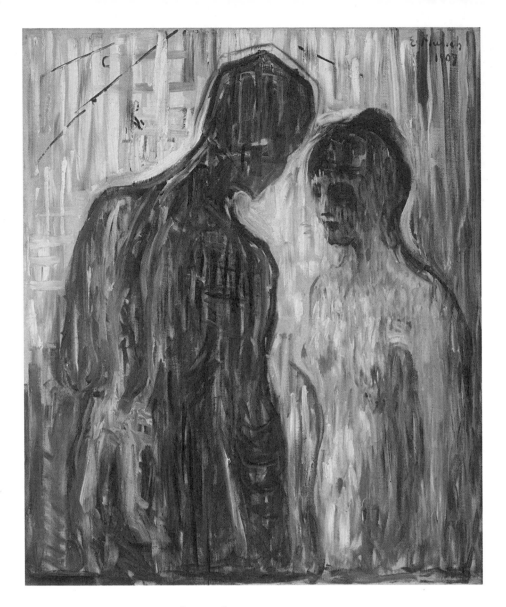

Cupid and Psyche (1907)
Oil on canvas
119.5 × 99 cm

This painting has a special place among Edvard Munch's love motifs, in the sense that it derives its theme from ancient mythology. The story of Cupid and Psyche dates back to the Roman author Apuleius in the 2nd century AD, but has a much older origin. Cupid is the Roman name for the Greek god of love, Eros, while Psyche in Greek means "soul". Apuleius's text was rediscovered in the mid-14th century in Florence, and this myth became a popular motif in European literature and painting during subsequent centuries, all the way up to the 19th century and Munch's time. Munch may have been inspired by the artist Max Klinger's series of etchings related to the theme from 1880.

The picture's rather unusual reference to Greek mythology also shows Munch at his most experimental and innovative in a painterly sense. One of its foremost features is how he refines and experiments with the brushwork. We see this in several other works from the same period. Munch's experimentation can also be understood as a response to the radical changes that occurred in painting during this period, in Henri Matisse's work, the so-called Fauvist painters and German Expressionism. Briefly explained, one can summarise this development as the liberation of colour and the brushwork.

The motif is systematically built up of broad, vertical brushstrokes that alternate with areas where the unpainted canvas shows through, in such a way that the picture as a whole has a striped effect. In some places the brushstrokes are shorter and more disrupted, in others applied across the vertical strokes, like crosshatching, which creates a feeling of depth and volume. In some places the brushstrokes are looser, more gliding and not so rectilinear. This applies in particular to the male figure's back, where in some places the brushstrokes appear like a maze, at the same time as the figure is held together by strongly defined contours. In many places Munch has used abundant amounts of paint, so the brushstrokes are nearly in relief. The picture surface thus shifts from transparent to saturated and nearly sculptural. We see the male figure from behind; in dark silhouette against the white light that spreads between the two figures, from a source we cannot see. The light falls across the woman's body, which dissolves in a flickering array of white and yellow nuances, in contrast to the striking primary colours in the remainder of the picture. The motif is a reference to a decisive pivotal event in the myth. Psyche receives nocturnal visits from Cupid, who has fallen helplessly in love, but who at the same time has strictly forbidden her to ever attempt to see who he is. In the end she decides to find out who he is, and one evening when he has fallen asleep, she lights an oil lamp in order to see him. She is so struck by Cupid's beauty that she fumbles and spills a drop of the hot oil so that he awakens and leaves her. Now a host of arduous trials await Psyche, before she can finally be resurrected and reunited with her divine love.

In the story the two lovers are reunited in the end, as Munch's portrayal – more uplifting than many of his other love motifs – so poetically expresses.

Many think of models as the artist's tools and instruments, a sort of advanced version of mannequins, who can pose in positions determined by the artist. This view greatly underestimates the role of models. For Edvard Munch they were important on many levels. They played an indisputable role in his private life. After he returned to Norway in 1909, he lived for long periods in extreme isolation. He was sceptical of strangers, and even friends and relatives were rare guests in his house. Despite the fact that he could be sociable, friendly and humoristic, he admitted repeatedly that he had problems associating with people. With this as a backdrop, the models' constant proximity represented an association with others that was advantageous for him, precisely because it was company that he could control: if he was not in a mood to paint one day, he could simply chat with them. If he wasn't up to chatting, he could ask them to leave. They were paid in any case. He paid them well; the models earned considerably more from him than they would have at the art academy.

The most important factor was, nevertheless, the artistic function the models represented. Why did Munch use models at all? He was a skilled draughtsman; he had drawn the human body every day for years. If he wished, he could produce them on paper from memory, as if by magic – men and women, young and old, overweight and slim, sitting, standing or reclining. Nevertheless he needed them because something occurs between the artist and the model, a form of communication, an undefined exchange of experience or atmosphere. A good model can influence the creative process, and contribute to putting their mark on the finished work.

Munch's models are not only present in thoroughly developed paintings. They also appear in hundreds of rapid sketches, most often nude drawings that are not drafts for larger works, but have an important function in themselves. A ballet dancer has to conduct his or her daily repetitions and basic exercises in order to be able to perform in a ballet. Munch needed to maintain his drawing skills; he needed to sharpen his gaze and concentration in order to work resolutely with larger compositions.

Some of these rapid *croquis* drawings are incomplete, unsuccessful. Set aside, yet not discarded. Others are executed with an ease and elegance that can take your breath away. This is Munch in his most relaxed state. He does not have to prove anything, he is just doing what he loves to do: draw.

But no matter what purpose they served him, the models had to have something to contribute – something that caught Munch's interest. They had to possess a special radiance, an ability to be mentally present, an aptitude for concentration. They had to have an aspiration to inspire. Those who were so lucky as to become part of Munch's "stable" of models must have been precisely this type of people.

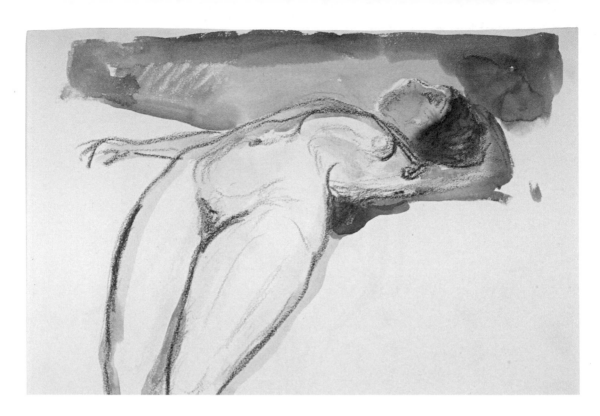

Reclining Female Nude (1910)
Watercolour and crayon
272 × 370 mm

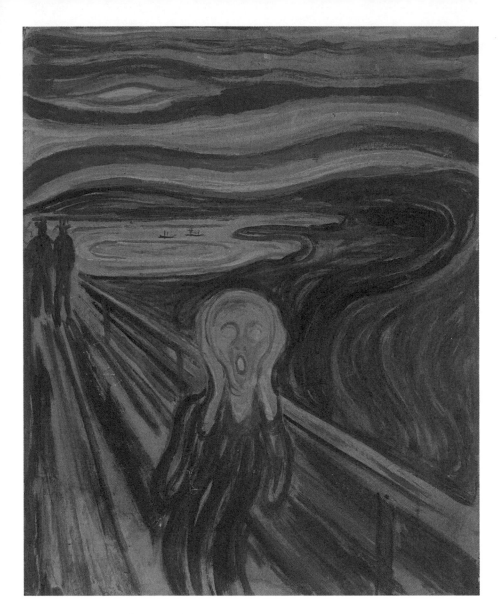

The Scream (1910?)
Tempera and oil on unprimed cardboard
83.5 × 66 cm

Edvard Munch's *The Scream* is known throughout the world, although his name often is not known as its creator. Reproduced innumerable times, its central undulating figure with hands raised to head and mouth agape has been transformed into blow-up dolls and coffee mugs, has appeared in cartoons and political fliers, has been tattooed on arms and backs, has decorated the labels of beers and wines, and generally has entered the realm of ubiquitous popular imagery forever undergoing new applications and making new appearances, freed of historical origins, taking on a life and identity surely never imagined by its creator.

Munch first exhibited the painting in Berlin in 1893, as the terminal image of the painting series Die Liebe, which pictured a man's perceptions of a love affair from its initiation to its horrifyingly depersonalising termination. Throughout the 1890s, Munch altered and added to the series until, in 1902, it contained 22 paintings subdivided into four categories: Seeds of Love, Flowering and Passing of Love, Anxiety, and Death. Placed within the frieze-like arrangement of the paintings, at the threshold between the realm of love's transformations from the sweetness of its beginnings to the radical bitterness of its ending and the realm of death, *The Scream* marked the transition from the experiences of life and love to the experiencing of dying and death. As such, it was central to concept and imagery of the cycle of paintings later called The Frieze of Life.

For many years, Munch resisted selling the individual paintings of his cycle. The first *Scream* painting seems to have been separated from the series. Nonetheless Munch did not have it in his possession in 1902 and requested that it be made available to him from the Norwegian collector Olaf Schou. Thereafter, however, he retained possession of it until 1910, when he re-sold the painting to Schou, who donated it to the Norwegian National Gallery. Only after that, not wishing to be without the key image of his Frieze of Life again, did Munch paint a new version, the one now in the museum's collection, first exhibited in 1918 and retained by him until his death. Although Munch largely duplicated the elements of the first painting and significantly adapted its stylistic approach, different in character from what otherwise he had developed by 1910, it contains stylistic aspects that differ from the original as well as changes in the motif that indicate that Munch painted the new version in 1910 or slightly later.

The Sun is the first monumental version of the motif that has place of honor in the front of the University Aula and was the version that Edvard Munch installed at the time of the 1911 competition. It stands as one of the most abstract and spectacular paintings that Munch produced.

In *The Sun,* Munch visualised the impossible. To gaze upon the solar disk is to invite blindness. To glance at it is to create, in the eye, a staccato trail of afterimages that inevitably fade. To paint the sun, and to invent patterns that replicate the sense of seeing and having seen the glory of the light, is an extraordinary feat. Concentrating the brightest and coolest blueish-tinted whites at the center of the solar disk, in contrast to the slightly warmer tone of the prepared canvas, Munch invested in the painting the sensation that it literally radiates light. The lines that extend outward from the center, which have the urgency of Italian Futurist "lines of force," and the concentric circles in the sky, read as abstract signs for spectral energy. Poised on the line that separates water from sky in the vast landscape, bracketed by wave-like forms that constitute rocky outcroppings, the sun appears to exert a centrifugal force, bending the symmetrical scene in an almost filmic manner. Munch laid down the rainbow-coloured paints in parallel bundles, juxtaposing contrasting colours to achieve the most vibrant optical effect.

This motif was inspired by the rocky coast of Kragerø, one of the towns where Munch lived in the years that he worked on the university project. After exploring several potential motifs to serve as the centrepiece of the university murals, Munch developed this image as a literal symbol of enlightenment, the perfect embodiment of the university's aspirations. Coaxing growth from the vegetation, and illuminating the water's surface, the sun is also the ultimate symbol of vitalism, the animating force of all other substances. The sun was also the focus of some of the university's most prestigious scientific enterprises, as Norway had been newly established as a centre of electromagnetic research through the work of professor Fridtjof Nansen, the polar explorer, and professor of physics Kristian Birkeland. Munch's sun consequently fused a veneration for the national landscape with the university's modern scientific identity. In its vibratory colours and freely applied lines, *The Sun* is Europe's largest expressionist painting.

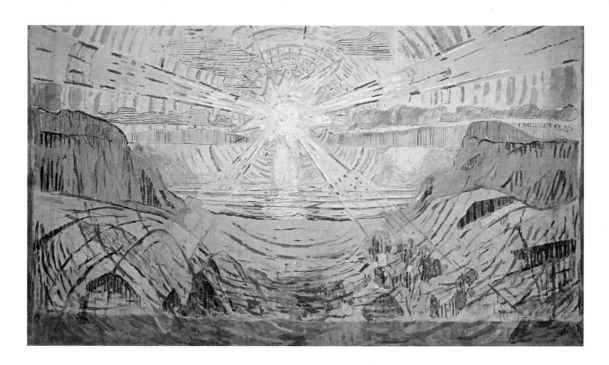

The Sun (1910–11)
Oil on canvas
447 × 775 cm

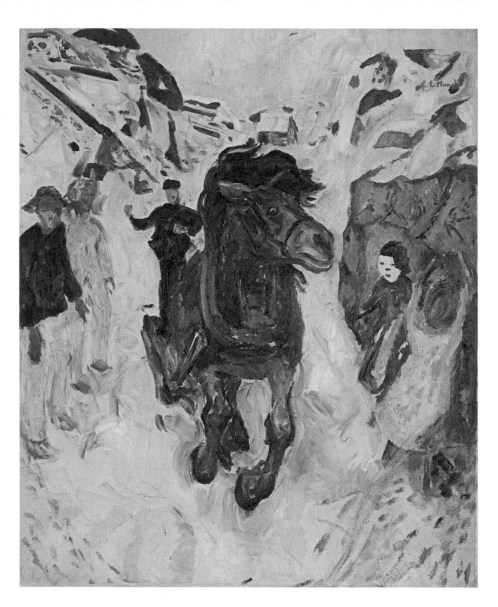

Galloping Horse (1910–12)
Oil on canvas
148 × 120 cm

A galloping horse, furiously approaching the picture plane, almost scaring the painting's viewers as it stampedes towards them. It frightens the people around it in the picture. How is that possible? In a painting, a horse cannot gallop; it can only appear to do so, in a stilled, "pregnant" moment. So, the viewer has nothing to fear. And yet, even if we don't feel it, we see fear; fear is "in" the image.

I propose to consider this a "cinematic" painting. By the time Edvard Munch painted it the cinema was an established feature of urban life. Even before its invention, artists creatively imagined and "imaged" situations that called for that invention. Therefore, I take the term "cinematic" not as a concept that explains the paintings, but as a frame; as an entrance into a mobile relationship between image and viewer.

What is a moving image, and what makes an image moving? The former question asks about the agency, effect and mode of existence of images; the latter, about the relationship between image and viewer, the viewer's agency and his or her position in relation to the image, including in the affective or emotional domain. The words "fear is 'in' the image" bind these two questions together. That bond is what makes *Galloping Horse* a cinematic painting.

The two questions have very different answers, and the primary point is to bring these together. Cinematic means moving in the senses mentioned, which the more common word movement cannot combine. The word "move" here underscores the fact that thought and argumentation are also forms of movement. This intellectual movement can help us to better understand thinking itself, unfolding through "moves".

While the horse has sharply distinguishable features and an eye that signifies the fury of the wildly running animal, its driver and the children on the right are barely readable blurs. Nevertheless, the childlike figure facing the viewer – some spots of red in a white patch indicating her facial features – looks terrified. Why do we see that terror in those vague blots? The other child's fear is hinted at by her turning away. Munch "argues" that visibility does not depend on sharpness. By positioning the two children in opposite directions, one frontal and one with her back to the viewer, the artist says that the whole body participates in the experience and subsequent expression of fear. The element of fear in the painting relates to the physical movement of the horse, which produces the fear, to the emotional movement of the children, who feel the fear. Moreover, we can only really imagine their fright if we stand between them, right in the middle of the picture. This flat convergence of two frightened figures is, thus, a direction-for-use of looking. We must migrate to inside the picture.

This motif was part of the mural cycle that Edvard Munch conceived as an allegory of education for the University of Oslo: *History* and the laboratory sciences represented on the west wall of the Aula, *The Sun* at the front, and, in Munch's words:

> *On the other side are the germinating energies – The fruit of wisdom is enjoyed – Wisdom nurtures (Alma Mater) – The thirst of knowledge is quenched [...] Alma Mater is still Alma Mater but may also mean Mother Earth [...] She delivers the milk of research –*

The woman at the centre of the composition who suckles a baby is simultaneously a symbol of the university (Alma Mater), the universal animating force (Mother Earth), and dressed in red, white and blue, a symbol of the nation. A figure drawn from National Romantic imagery and allied with groups of naked children – the investigators of nature – the mother embodies Munch's declaration that the Aula murals should be "specifically Norwegian and universally human".

The Researchers was the most challenging of Munch's motifs for the Aula, and one with which the artist struggled for over 30 years. It has a complicated "biography": Munch sent this version of *The Researchers*, painted in the summer of 1911, to the competition in August. He had used a different version earlier that year in a test hanging in preparation for the jury's selection process. Yet a third version, entitled *Alma Mater*, was installed at the university in 1916, after it and the other ten murals were donated to the university. That version now hangs in the Aula as the definitive interpretation of the motif. There are, all told, three variations of this motif in full scale. Munch expressed discontent with *Alma Mater* and installed this painting over it in 1926 so that a jury could determine which version best suited the hall. Taken down in 1927, Munch again had this painting installed in 1939. After the Germans overran Norway in April 1940, both this painting and *Alma Mater*, as well as the other university paintings, were taken down from the walls and evacuated for safe keeping. After the war, this painting entered the City of Oslo Art Collections as part of Munch's legacy and *Alma Mater* was retained by the university. When in 1963, the first Munchmuseet was built, its auditorium was specifically constructed on a scale to accommodate this monumental canvas.

When Edvard Munch returned home to Norway in 1909, he was fascinated for a long time by the winter landscape. With few exceptions, he had for many years spent the winter season on the Continent, and now he took up again the Norwegian winter, with its snow and cold, and sharp, clear colours, in a number of paintings. The blue-white snow provides a powerful contrast to trees and dark mountain ridges, or humans pursuing outdoor activities.

In the winter of 1912 Munch painted two relatively sketch-like pictures of hewn logs in a forest outside Kragerø. Both of them were included in his exhibition at The Artists' Association in Oslo in March of that year, and both were sold to private collectors.

He later developed this motif in a large, monumental painting where the debarked logs lie glistening yellow on the snow-covered forest floor. While the logs in the two earlier versions point in every direction, here the biggest log is placed in the middle of the picture and depicted greatly foreshortened with striking lines of perspective that lead the viewer's gaze inward into the picture. This pictorial device causes the log to look like it is moving when you walk past the painting while keeping your eyes fixed on it.

Such a radical use of central perspective can perhaps be viewed in connection with the fact that, between 1910 and 1916, Munch was busy designing large wall panels to decorate the University's ceremonial hall, the Aula. On large surfaces that can be seen from many angles, it is important that the picture appears "correct", regardless of where in the room the viewer is standing, and it is reasonable to assume that Munch explored this problem in other pictures as well.

We don't know for certain when this last version was painted – presumably shortly after the first two, but the picture was not shown to the public until February 1916. During this period Munch often took up everyday motifs, which he transformed into brilliant tributes to the labourer and to fertility. In large, monumental compositions he painted the farmer in the cabbage field, the haymaker, the women binding sheaves of hay, construction workers with picks and shovels and lumberjacks felling trees without the help of large machines. In *The Yellow Log* the workers have finished the first phase of their work, and the logs lie there with their branches and bark removed, waiting for the timber drivers to arrive with horses and sleighs to haul them away.

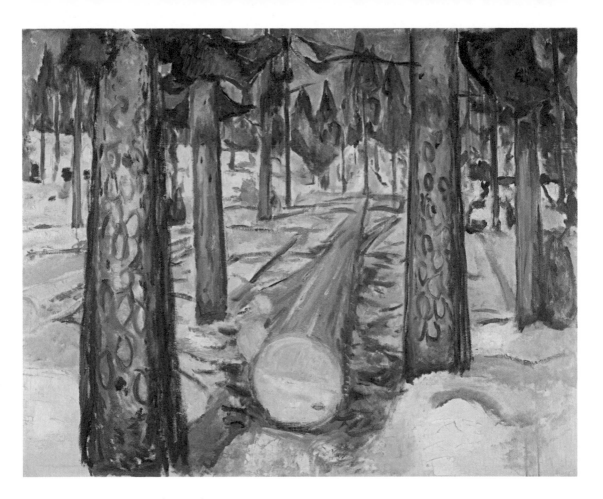

The Yellow Log (1912)
Oil on canvas
129.5 × 159.5 cm

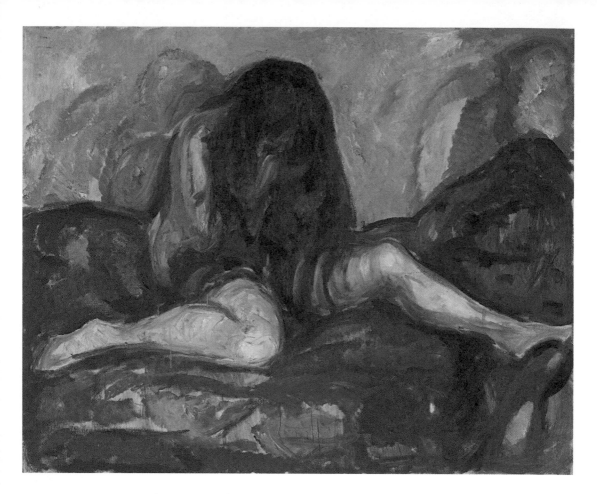

Weeping Nude (1913–14)
Oil on canvas
110.5 × 135 cm

To paint from a live model appears to have been particularly inspiring for Edvard Munch. This must be one of the finest paintings he has ever made! At least in a painterly sense, it shows Munch at his most lavish and free. Large shapes, expressive, saturated brushwork and striking colour contrasts characterise the picture's painterly landscape. This intensity matches the picture's emotional drama as it may be deduced from the model's body language. She hides her head in her hands and weeps, if we are to believe the title. This occurs with a wild abandon corresponding to the dark, unruly hair. It cascades forward, almost like a waterfall, concealing her face.

The soft bedspread is painted in bloody, saturated red tones – carmine red and cinnabar red alternately. Added to this are elements of more transparent pink tones and areas where the white primer of the canvas shines through. The brushstrokes partly follow the wavy shapes of the blanket, while simultaneously creating a more varied and chaotic structure in the foreground. The bedspread is like an agitated ocean under the stooped figure. In an extreme contrast of colours, all that red encounters a formless blue-green mass on the right. It could be a pillow, or perhaps a blanket? The red and the green form the main colour contrast, accompanied and conveyed by the lighter tones in the background and in the figure. Behind the model we see a shifting pattern of loosely combined areas of red, pink, violet and brownish tones, partly an echo of the bowed back. The legs that protrude out from the dark hair are painted with green contours and modelled with softer nuances of pink and white. The yellow colour of the left foot creates a contrast to the blue-violet areas in the background, so red and green are not the only complementary colours Munch brings into play here.

The model in this painting is most likely the young Ingeborg Kaurin (1894–1972), who was also Munch's housekeeper from around 1911 until she married in 1915. We recognise her posture in several of his other paintings. Among them is *Melancholy. Weeping Woman on the Beach*, where we see a female figure sitting on the beach, leaning her head in her hands, with her long hair hanging down. Munch made a new version of *Weeping Nude* in 1919, five years later. Here the model kneels on the bed, and the picture's colour scheme is built up with blue and yellow as the domineering contrasts. The gesture of the bowed head is also found in a number of works with the model standing in full length, among them a series of paintings entitled *Weeping Woman* from 1907 and several pictures entitled *Model by the Wicker Chair* from the years 1919–21. These are some of Munch's most significant nude pictures. The fact that the motif shows up in various versions again and again, over a 20-year period, must mean that it fascinated him and that he felt a need to explore the possibilities it offered. As a blueprint for an expressive motif it is charged with emotional pathos, at the same time that it clearly spurred him to create new paintings.

They advance towards us with an unstoppable momentum, nearly threatening to roll over us. A procession of dark and solemn men in everyday clothes, on their way home from a day's work at the factory, fills the narrow street. The surroundings are barren and the sky grey. Naked house walls frame the street on one side, while on the other a high fence recedes into the picture. The diagonal lines that run through the motif radiate out from the same point and define the picture's central perspective.

The three male figures at the forefront are each portrayed in a different perspective. The figure in the middle is seen from above, with one leg greatly foreshortened, in a furious forward lunge. The man to the left is standing more calmly, at eye level with the viewer, while the man on the right is on his way out of the picture "below" us. We are thus drawn into, and become part of, the motion in the picture. The legs of several of the figures are partly transparent, as is more or less the case in the remainder of the motif. It's like doubly exposed photographs, where several motifs lie on top of each other, something we can also see in many of Edvard Munch's own photographs. Together with the dramatic perspective, this painterly device is used to give the impression of movement. The chaotic and vigorous movement seems, quite simply, to be Munch's main concern in *Workers on Their Way Home*.

During this period many avant-garde artists wished to depict the dynamics and mobility of modern society. Munch was particularly inspired by the way in which two modern visual mediums portrayed movement. These were photography, which he had experience with himself, and not least film. Photography's ability to freeze a moment made it possible for the first time to show the individual parts of a movement. In contrast, early film is dominated by scenes where a train, a horse and buggy or a crowd of people appear to jump out of the cinema screen. It was a way to demonstrate the new medium's striking and almost frightening ability to depict life-like movement. One of the first films of the period, made in 1895 by the Lumière brothers, appropriately enough shows "workers leaving the factory". In a sense, the picture is a kind of painterly response on Munch's part.

Workers on Their Way Home is typical of the times also in the way it focuses on the worker as a new figure in society. The labour movement was making great advances at the time, and this is something Munch acknowledges in his art, although he never commented explicitly on politics. The worker is a motif he dealt with for many years. He was well acquainted with workers from his childhood in Grünerløkka, a working class neighbourhood in Oslo. Workers on their way to and from work is a motif that shows up already in his earliest sketchbooks. When Munch painted this picture he was living at Jeløya in Moss, where he might encounter workers in the streets on a daily basis. He also worked on a new version of *Workers in Snow* – his first monumental motif depicting workers from 1909 – and the motif would continue to follow him until around 1930.

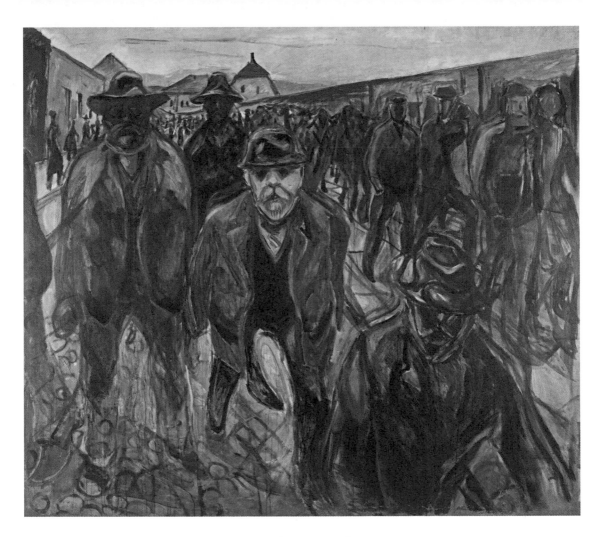

Workers on Their Way Home (1913–14)
Oil on canvas
201.5 × 227 cm

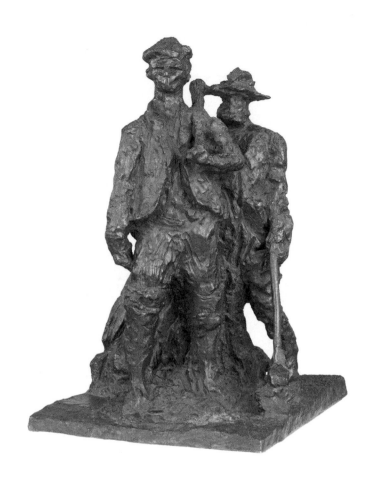

Workers in Snow (c. 1914)
Bronze
70 × 45 × 56.5 cm

Edvard Munch most likely modelled small figures in plasticine as early as 1903, but it wasn't until he settled in Kragerø in 1909 that he began to use clay as a means to make drafts for small sculptures. On 11 May 1910 he wrote to Gustav Schiefler to tell him that he had begun working with sculpture, enclosing a photograph of himself standing beside a sculpture group composed of a seated "Mother Norway" and a standing young man, intended to symbolise Norway's independence. Longstanding plans to create an Eidsvoll monument to commemorate the centennial of Norway's constitution in 1914, resulted in several competitions but ended without result. In 1908 the competition was for all practical purposes opened up to almost anyone to submit drafts and ideas, and in the course of 1909–10 several proposals for such a national monument were made public. Munch eagerly followed this development, and although he never sent in a proposal himself, sketchbooks from this period are full of drawings that clearly revolve around a monument to commemorate Norway's independence. These ideas blended to a certain degree with those he was simultaneously working on for the University's Aula decorations.

The sculpture group of standing workers was first executed in a sketch-like painting in 1909, which was also presented as a draft for a decoration. In 1910 the motif was developed further to form a monumental painting of workers as the representatives of a new, emerging social class. In 1912 this painting was sold to a well-known German art collector, and in the period 1910–12 Munch repeated the motif in woodcut and lithography. A new version was painted some time between 1913 and 1915, at approximately the same time as he modelled his workers in clay.

The sculpture was cast in plaster at Munch's residence at Jeløya in the summer of 1914, and based on a note in Ludvig Ravensberg's diary entry for 28 September 1914, stating that it "has already been cast in plaster", it seems likely that it was modelled relatively shortly before being cast, and in any case after Munch rented Grimsrød manor at Jeløya, in March 1913. The sculpture is not large, only 70 cm high, and modelled in a visually striking impressionist style. There are no clearly defined volumes here, and one can sense that the artist was a painter and not a sculptor. But the sculpture is full of life, and the uneven surface gives the impression of movement and variation.

Around 1930, Munch took up the motif of a group of workers again, and painted a large draft intended as a potential decoration for Oslo's City Hall. In 1932, presumably two versions of the sculpture were cast in bronze at the Oslo Bronze Foundry. In 1943, shortly before Munch died, the Freia chocolate factory bought one of them and placed it in the so-called Freia Hall containing wall paintings by Munch. He had originally also made a draft for a workers frieze to decorate a smaller lunchroom in the Oslo factory, and the sculpture may perhaps be considered as a small compensation to make up for the fact that the administration declined to acquire the frieze in 1920.

In *Cleopatra and the Slave* Edvard Munch depicts an athletic male of African origin next to a fair-skinned woman reclining on a bed. The picture calls to mind paintings from 19th century French Orientalism, but can also be considered an allegory on the history of slavery and colonial notions about sexuality across ethnic boundaries.

Sultan Abdul Karem sat for the motif after he met Munch during his visit to Kristiania in 1916. Karem was a member of the troupe belonging to one of the largest travelling circuses in Europe of the period – the German Circus Hagenbeck. We do not know the nature of Karem's work at the circus for certain, but it is quite feasible that he participated in one of the circus's many ethnographic performances. At the time such large-scale performances were common, and the circus regularly toured with representatives of so-called "exotic peoples". After an exhibition of Sami people in 1874, Carl Hagenbeck specialised in what would later be called "Völkerschau" – in English often referred to as "human menageries". Rather than arranging exhibitions based on different cultures, all-around performances were created that played on colonialism's stereotypical fantasies about "primitive others".

Precisely where Sultan Abdul Karem hailed from is unknown, but it is reasonable to assume that – like many other members of Circus Hagenbeck – he was brought to Europe from one of the German colonies in Africa, such as today's Tanzania, Namibia or Cameroon. Munch's friend Rolf Stenersen insinuated that Karem might have come from Ethiopia.

In Munch's representations of Karem's body, one can sense a certain fascination for "the exotic other". The model's muscular physique and erect posture bring to mind the period's stereotypical and racist view of African men as being particularly virile. The composition with the caricatured "wild" and "primitive" man in the background strengthens this impression, and the connotations the image elicits regarding "race" and sexuality are underscored by the fact that Cleopatra is depicted as a white European woman. With this "race combination" Munch not only evokes Karem's "otherness", he also plays on the contemporary sexual fantasies about African men and the imagined threat this represented to white European masculinity. Although Munch hints at stereotypical and even racist notions of sexuality in this picture, we do not know what he actually meant by the motif. Munch also painted three portraits of Karem, in which the artist moves past the stereotype of "the exotic other" and depicts Karem as an individual.

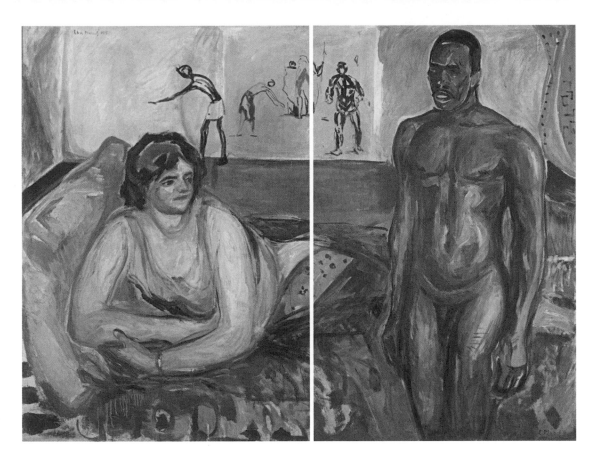

Cleopatra and the Slave (1916)
Oil on canvas
146.5 × 102.5 / 145 × 90 cm

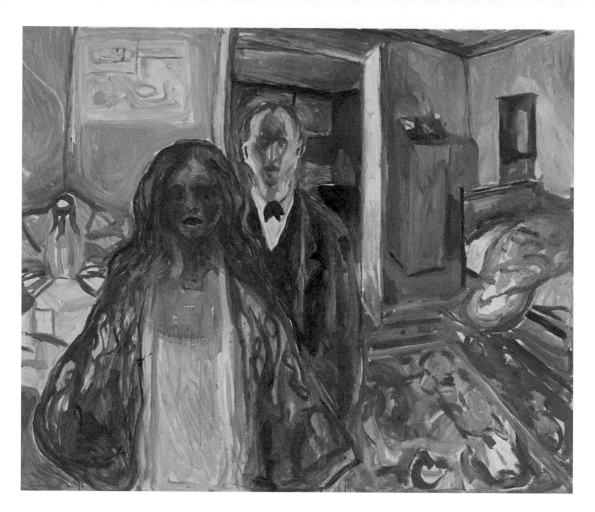

The Artist and His Model (1919–21)
Oil on canvas
128 × 152.5 cm

In this picture Edvard Munch depicts himself in a dramatic scene. That is to say, the drama does not exist in an external sense, but in the restrained tension between the older artist and the young model. This relationship is the picture's psychological and erotic centre of focus. The room they are in appears to be tilting outward; it bulges as though about to burst. The interior is taken from Munch's home at Ekely, and this adds a degree of domestic intimacy to the scene.

The male figure is formally attired, in a dark suit, white shirt and black bow tie. He seems bitter, with a serious and determined gaze. He stands as though frozen in place. The face is drawn up with a few brushstrokes, sharply illuminated on both sides, while the rest lies in darkness. This, in contrast to the young model who, compared to his formal attire, is rather intimately and lightly dressed, as she stands directly in front of him facing us. The facial expression is more open and ambiguous – the dark gaze seems both despairing and fearful. The face lies in shadow, as though bloated and full of movement. The eyes are like bottomless pits, while at the same time her cheeks are flushed and her lips red. She is the sensual eye-catcher, described in billowing lines, with the dressing gown open over a sheer slip.

Both of them are facing the viewer, standing close together. Despite the physical proximity they are somehow isolated from each other, at the same time as an intense exchange is being played out between them.

The picture is a cornucopia of painterly devices, which together with the dramatic pathos makes it one of the highlights of Munch's production. In that sense it's strange that it was never exhibited during his lifetime. Thick brushstrokes and striking applications of
colour in red, blue and green are in contrast to areas where diluted, dripping paint just barely covers the white primer with translucent veils of pink and light blue. A vividly patterned carpet, arrangements of small objects, an unmade bed – and the fact that one can see into the room in the background – create small secondary narratives that add nuances to the whole.

In this work Munch treats his relationship to the model explicitly, and it appears as though he acknowledges his own erotic desire. More specifically, it is probably the young Annie Fjeldbu (b. 1897) Munch has depicted here, who modelled for him during the years 1918–23.

Like some of Munch's other models, she also took care of his household. She has described how the eccentric artist might wake her in the middle of the night to ask her to sit for him. Munch has painted numerous variations on this motif of the artist and his model, and also drawn a number of studies. In one of the paintings he places himself in the foreground, with his hands in his pockets and wearing an obstinate mulish expression, like a bull in heat. It's as though he ironically caricatures his own lust. In another painted version, he has added a third person and transformed it into a motif about jealousy. One can thus say that the personal leitmotif in the picture generally belongs with Munch's many depictions of man and woman.

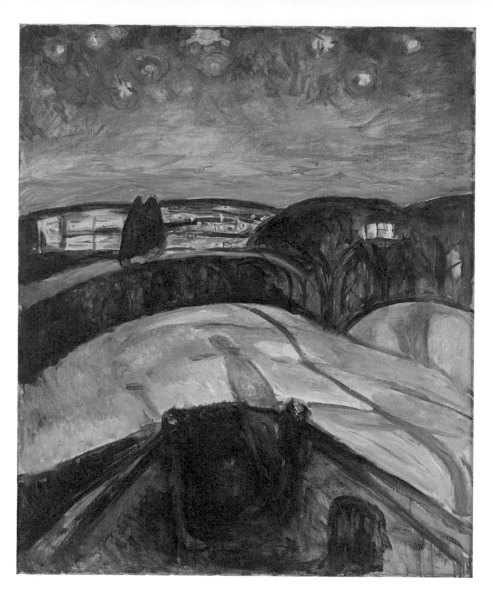

Starry Night (1922–24)
Oil on canvas
120 × 100.5 cm

There is poetry in Edvard Munch's nocturnal summer pictures from Åsgård-strand. Through an undertone of melancholy the strong emotions of youth surface – love, jealousy and longing. Man and woman meet in the dance of life, and then go their separate ways.

But in the nocturnal winter pictures from Ekely it's as though we have arrived at another stage in life. Poetry, yes, but it is the tranquil poetry of resignation and isolation. Reflection that comes with old age sets the tone.

Starry Night can of course be perceived as an evocative depiction of a winter night at Ekely. Yet if we give reign to our imagination, might we possibly find a few keys that open doors to hidden rooms? The stars in the restless nocturnal sky are themselves restless. Large, asymmetrical shapes hover up there like symbols of unknown worlds. What is most curious perhaps is the celestial body at the top and a little left of centre. Is it merely a large star emitting two rays, or is it possible Munch has included an echo of his own work *Encounter in Space*? About this motif he writes:

> *Human fates are like planets. Like a star that emerges from the dark – and meets another star – shines for a second before disappearing again into the dark – in this way a man and a woman meet – glide towards one another are illuminated in love's flames – to then disappear in their separate directions. Only a few meet in a single large blaze – where they both can be fully united.*

Munch lived during a time when electricity began to chase away the darkness of night. In *Starry Night* the glittering lights from the town interact with the cosmic lights above. Human creation in miniature against the supreme creation of the cosmos.

Munch's villa at Ekely had a glassed-in porch, with stairs leading down to the garden. It is these stairs we see in the picture. And it is the light from the windows of the house that creates the shadows in the snow. But there is something strange about one of these shadows. It appears to come from a person – but there is no one there to cast a shadow. And the shadow of a head on the right railing leading up to the porch; how should we interpret that? Is it a kind of concealed self-portrait? And in that case, why is it turned away from the panorama view he can see from his position at the top of the stairs? These "impossible" shadows apparently live a life of their own, like the shadow in *Self-Portrait. Quarter Past Two in the Morning*. These hints of a ghostly presence create an atmosphere of winter cold and loneliness, while simultaneously giving us the feeling that Munch is present in his own picture.

Perhaps he often stood looking out at the stars: "One becomes accustomed to everything – also to the star – the same star – every night without fail – I wonder if one can become accustomed to death –".

The bride is surrounded by men. Some have skin-coloured faces; two have a red face. The one man who has picked up his umbrella and is leaving the scene is half-green, with closed eyes, the corners of his mouth turned downwards. Although she is the only figure with an upright body and her face straight ahead, the bride looks miserable. What is it that creates loneliness here?

She is both the main figure, standing out in her bright dress and central position, and an alien element in the otherwise exclusively male party. The woman with her arm stretched out is both isolated and stilled. Her eyes seem closed, her lips a red smear of badly applied lipstick. Her face is mask-like. The man on our left is looking creepily at her, as if arrogating authority over her.

This is the most "classical" of Edvard Munch's larger compositions. As a cinematic scene and a history painting, it places the figures at a table and makes them all seem involved in some event or plot. Gossiping about the bride (on the left); the three near her are looking critically as if to ridicule her. The man next to her on the right is bowing his head. We can add the two half-cropped figures on the paintings on the wall behind the table. These paintings within the painting, a small one on the left and a tall one on the right, are both headless, yet clearly show male figures. And the flicker of light on the right, behind the bride, seems a camera's flash. What it erases from visibility is yet another painting, signposted by a thin line ending, on the upper edge, with side edges showing some curving, indicating stretching.

More surface space is devoted to the top of the table than to the figures. Yet it lacks space; it is slightly askew and cropped at the bottom left corner. The cropping and the wonkiness emphasise depth; it doesn't quite fit in the frame. Its depth is foregrounded even more by the reflections of the glasses, which go in all directions, producing the spectre of a lamp above the table, which we can only infer. Also, the table ends in drippings, falling from the edge of an unevenly painted tablecloth at the left. The drippings make the table seem tilted forward, the depth reduced. The table's edge comes closer to the viewer. The drippings flatten the image's surface. This creates a dialogue between figuration and abstraction through flatness and with colour.

The festive dinner table becomes a prison. This is the meaning of the unreadable painting, blinded by a photographic flash light. Locked in between that flash light in the background and the drippings in the foreground, Munch's bride is crushed flat in spite of the too-far-reaching perspective of the table.

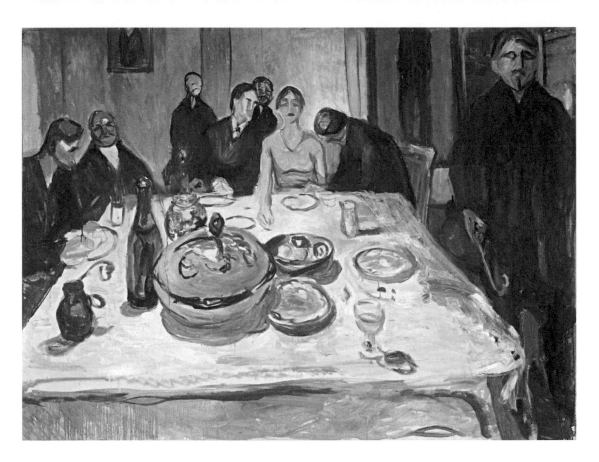

The Wedding of the Bohemian (1925)
Oil on canvas
134.5 × 178.5 cm

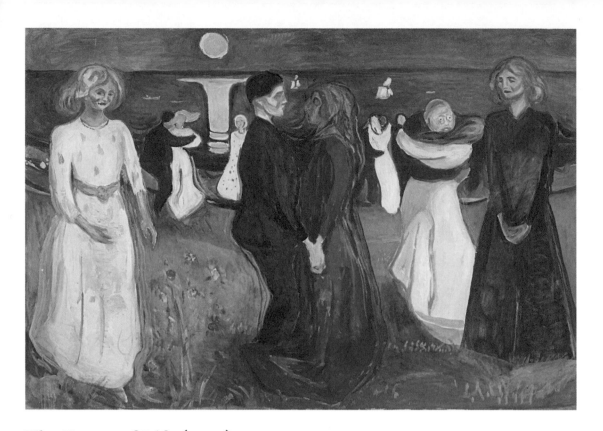

The Dance of Life (1925)
Oil on canvas
143 × 208 cm

The Dance of Life reprises and reinterprets a motif that Munch first painted in 1899–1900. An existential statement embedded in the bodies of three women, or three versions of one woman, it was among the last of the motifs that Munch conceived for The Frieze of Life.

Read left to right, the passage of human time and biology are suggested by the representations of the virginal women, dressed in white, the woman at the center, dressed in red and dancing with a male figure, and the black-clad woman facing toward the dancing couple. The setting was inspired by the shoreline near Munch's house in Åsgårdstrand, a scene of revelry on a summer night in which the artist perhaps pictured memories and musings of his youth. He evoked the motif in several texts, including one that appears in a late sketchbook: "I danced with my first true love: it was the memory of her. In comes the smiling, blonde-haired woman who wants to take away the blossom of love, but it does not permit itself to be picked. Over on the other side she, dressed in black, looks in sorrow at the dancing couple. She is an outcast, like I was cast out of her dance; and at the back the raving mob caught in wild embraces."

The first version entered the collection of Oslo's National Gallery in 1910. 15 years later, according to the records of that museum, Munch used the painting as the direct model for this larger and more ferociously painted version. This variation is rendered in the keyed-up palette and diverse painting techniques that characterised Munch's paintings of the mid-1920s. The pink-violet sky, reflected on the surface of the water, forms an eerie backdrop for the dancing couples and the standing female figures, all of whom are animated by contour lines that have spun off from their bodies to swirl at their edges.

This was clearly a motif that preoccupied the artist, as he returned to it several times, including variations for the frieze for the home of Max and Marie Linde in 1904 and for the public vestibule in Max Reinhardt's Berlin theatre. The title of the motif calls forth a universal existential condition. However, the figures are conventionally read as Munch's interpretations of Milly Thaulow, with whom the artist had his first sexual liaison in the 1880s, and Tulla Larsen, with whom he was involved when he created the first version of this motif, and at the centre, a stand-in for the artist himself.

Perhaps inspired initially by contemporary literature (the Danish writer Helge Rode had sent his 1898 play *Dansen Gaar* to Munch), the motif of 1899–1900 was a semi-fictitious memory of the artist's past. By 1925, when Munch painted this version, it was a memory of a memory, an allegory of human existence as filtered through bittersweet reflection.

When everything has burnt, when the fire and the flames have been extinguished, when passion and love are spent, ashes are all that remain. The painting *Ashes* can be interpreted as a visualisation of an impossible love affair. The man in the left corner can no longer, or will no longer, and a despairing woman tears at her hair as though unable to comprehend the situation, or why the man is acting the way he does. The man turns away, concealing his face. Perhaps he is ashamed – ashamed of his inadequacy, which makes it impossible for him to stay in a relationship.

Edvard Munch belonged to the same generation as Sigmund Freud. Parallel to Munch's visual self-analyses, Freud developed psychoanalysis and brought forth theories about how trauma and childhood experiences can leave a mark on our lives and explain neurotic disorders. Freud believed that early childhood in particular was decisive for behaviour and reactions later in life. In his imagery, Munch reveals how he has been affected by illness, loss and death during his childhood. Freud's psychoanalytic theories allow us to intuit how his mother's death may have influenced Munch's relationships with women in his adult life.

The French-Bulgarian philosopher Julia Kristeva reveals in her theories about depression and melancholy how the loss of a mother, in particular, can cause one to become susceptible to melancholy. Grief may conceal aggression towards the lost object, and in new relationships, memories of the loss are awakened, memories that in turn may bring about the following ambivalence: I love her, but I hate her, because I love her. Perhaps that is why love seems impossible for Edvard Munch?

Munch never married and never started a family. None of his turbulent relationships lasted. He was engaged to Tulla Larsen, it's true, but he broke the engagement under dramatic circumstances. After a period of rehabilitation at Daniel Jacobson's clinic in Copenhagen, he apparently put aside women, love and alcohol for good. Erotic love appears to have been too agonising for Munch.

Both Sigmund Freud and Julia Kristeva discuss how melancholy and depression can be catalysts for great art. If we set aside fear of women – or rather fear of love – what emerges is a chronic melancholic, who struggles with his mental health.

Munch engages in visual self-reflection and self-care; melancholy thus becomes both an artistic drive and emancipating therapy. Munch paints in order to survive, in order not to go under. In his unrelenting self-analysis he ruthlessly discloses his own vulnerability, thereby pointing to a shared human pathos.

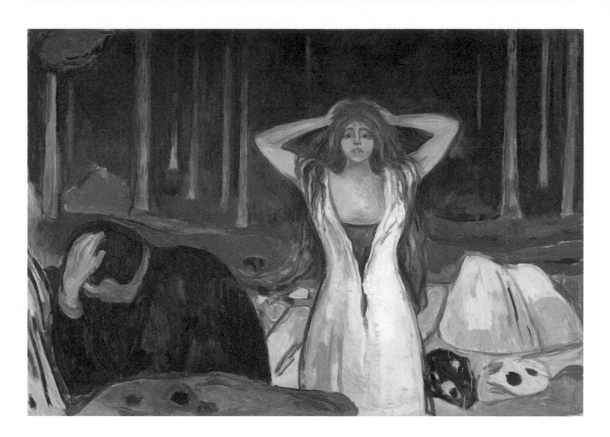

Ashes (1925)
Oil on canvas
140 × 200 cm

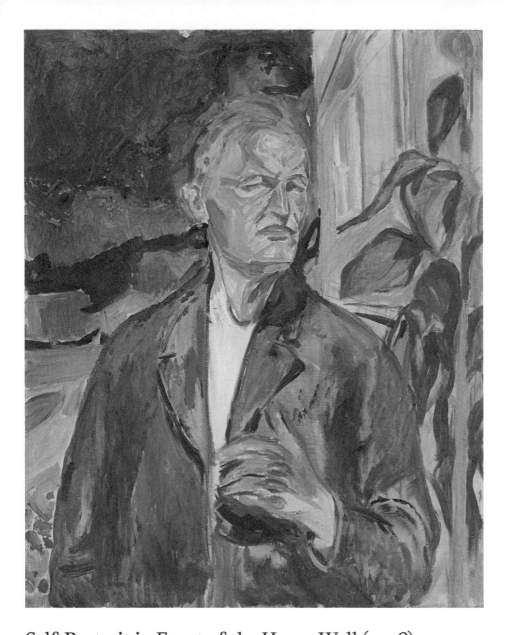

Self-Portrait in Front of the House Wall (1926)
Oil on canvas
92 × 73 cm

In this painting we meet Edvard Munch on his own turf. He stands in the sunlight next to the yellow Swiss-style villa on his own property Ekely, surrounded by trees, bushes and flowers. He is informally dressed in a simple jacket and undershirt, with his face turned slightly to the side and eyes squinting because of the sharp sunlight. His expression may seem dismissive, as underscored by the clenched mouth, the "determined", strong chin and the lifted hand that keeps us at a distance.

Keeping in mind the all-important significance of the sun motif in Munch's art, one might perhaps find something symbolic in the fact that he places himself in sunlight, something he also does in a series of self-portrait photographs he takes at Ekely four years later. As a further extension of the sun theme, he is even flanked by a tall sunflower in this picture, which we also recognise from an earlier quasi-self-portrait called *Bleeding Man and Sunflower*. Here the theme is related to a tormented artist who creates with his own lifeblood. *In Front of the House Wall* offers rather a form of self-representation that is somewhat official and representative.

The work was painted during a period characterised by retrospection in various ways, when Munch took up early motifs and themes again with renewed intensity. Among others, he painted new versions of The Frieze of Life motifs, such as *Ashes, The Dance of Life* and *Woman* as well as a major work like *The Sick Child*. During these years he was also busy going through his old journals and notes. As part of this retrospective project Munch was also the subject of several retrospective exhibitions, which finally won him definitive canonisation. This applies not least to his large exhibition in Berlin in 1927, which subsequently travelled to the National Gallery in Oslo. *In Front of the House Wall* was not included in this exhibition, but a variation on the motif was; one in which Munch has outfitted himself with brushes and a palette. The National Gallery's director Jens Thiis later commented on the "strident mood" and "combative physiognomy" in this version, something that can also be said of *In Front the House Wall*. One senses that the artist who presents himself in this painting is at the very peak of his career, self-confident and imposing.

As though to confirm this beyond any doubt, the picture is marked by a striking painterly vitality. The brushstrokes are loosely sketched and accurate at the same time, with a colour scheme that contains strong complimentary colours; blue against yellow, green against red. Munch demonstrates a colouristic "barbarism" that is akin to what he might have seen in a painter such as Henri Matisse, for instance. The features of the face are modelled with different shades of green, blue, red and ochre yellow. As a camouflage of sorts, these colours absorb the vegetal light and temperature of the surroundings. When he wishes to suggest the highlight on the brow, he does so with bravura, by precisely applying a saturated clot of paint there. The portrait's self-presentation is thus also a painterly form of boasting, where Munch demonstrates what he is capable of.

A romantic and peaceful atmosphere rests over the three young girls on the bridge. The diagonal positioning of them has the effect of drawing us into the motif's mystical and dreamy summer evening. They are wearing light summer dresses and stand with their backs to us. We cannot see their faces, yet we can sense that they are filled with dreams and longing as they lean over the railing.

"It is strange that the summer of 1901 has not been written about – It was the only peaceful summer I had in many years – The only happy summer I have had in my little house – That is when I painted the girls on the bridge, the women on the bridge, the large tree". The three adolescent girls gaze dreamily into the water from the footbridge that leads out to the steamship pier. It was completed in 1898; the year Edvard Munch purchased his little yellow summerhouse in Åsgårdstrand. Two of them are wearing white dresses, while the young girl in the middle is in red. It is a light summer evening, and the moon is visible above the roof of the neighbouring white house by the towering linden tree in the Kiøsterudgården's garden. The stately white house from the late 1700s soars above the property giving the motif character in the way the house and trees are reflected in the smooth water. If you visit Åsgårdstrand today, you can walk out on the modern pier and see the same house and the characteristic silhouette of the large linden tree.

Munch painted the motif for the first time in Åsgårdstrand in 1901, but as with many of his paintings there are several versions of this one, in addition to drawings and prints. The museum's picture is from 1927, and was made for inclusion in Munch's large exhibition in Berlin that year. He said that by repeating the same lines, shapes and colours, he wished "like a phonograph to make the evocative mood quiver". Small changes and adjustments in the various versions caused Munch to view these repetitions as an exploration of the expressive energy in each and every motif. Some of these pictures have a stronger degree of portraiture, such as the painting *The Women on the Bridge*, depicting more mature women, including a portrait of Munch's long-time friend Aase Nørregaard.

Munch waxes poetic in his portrayal of the Nordic summer night in conjunction with young girls. During the 1890s a movement emerged that led to the emancipation of children, and society began to show a greater interest in protecting their rights and needs. Depicting children in art was an innovative undertaking at the time. Munch was preoccupied with the psychology of children, something he demonstrates in his many motifs and portraits of children. He wished to depict them with dignity, and at the same time he wanted us to see the unformed character, helplessness and bewilderment of children in their development towards becoming adult human beings. *The Girls on the Bridge* takes this even further, in its portrayal of the dreaming girls on the threshold of becoming adult women. The bridge they stand on can thus be seen as a metaphor for the transition we all have to navigate through, from childhood, youth and adulthood to old age.

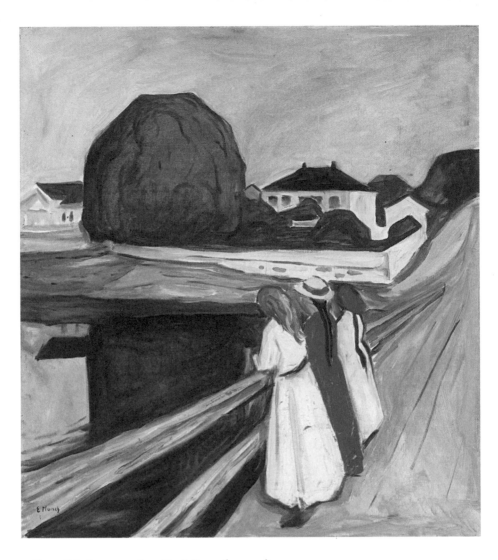

The Girls on the Bridge (1927)
Oil on canvas
100.5 × 90 cm

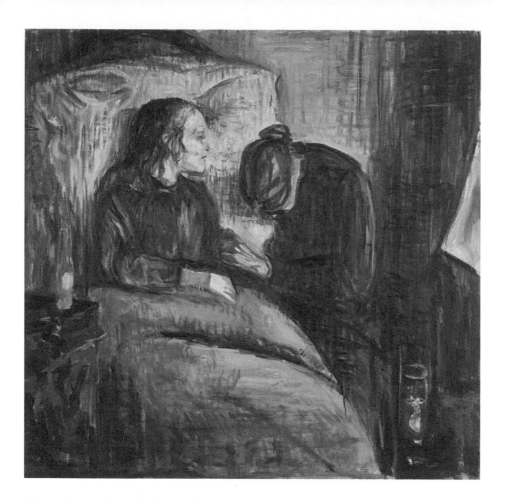

The Sick Child (1927)
Oil on canvas
117.5 × 120.5 cm

The motif of the sick adolescent girl is based on Edvard Munch's memories of his sister Sophie, who suffered from tuberculosis and died at the age of 16. Tuberculosis was a constant threat in society and in Munch's family – his mother died of the disease when the artist was five years old. There was no cure then. Munch painted the first version of *The Sick Child* in 1885–86, and according to his notes he worked on it for a long time. He wanted to reproduce his impression of his dying sister – her pallid complexion and reddish hair against the white pillow. He wanted to express something that was difficult to capture; the tired movement of the eyelids, the lips that seem to whisper, the little flicker of life that remains.

The painting's surface is characterised by a feverish creative process. Munch used a palette knife to scrape the paint and to paint over with. The deep vertical and horizontal traces in the surface testify to the fact that he was in a state of inner turmoil, as though he wished to eradicate his sister's death. Many vilified and criticised the picture when it was shown for the first time in the Annual Autumn Exhibition in 1886.

There are six versions of the motif, painted in 1885–86, 1896, two in 1907 and two during the 1920s. Munch most likely felt that he had not succeeded in covering all the different aspects of his memory of his dying sister in one picture. He felt that the colours in the first version were not vivid enough, too grey, "heavy as lead", yet the sensitively rendered grief without a doubt resonated most strongly here. The composition is the same in all of the paintings, stripped of unnecessary details. Later versions are more colourful and all of them differ slightly from each other – they contributed, every one of them, to enhance Munch's memory.

Our painting is most likely his last, sixth version of the motif, signed and dated 1926. Munch later believed that he had painted it in 1927. The main focus of the painting is clear, and has few details. The sick adolescent girl is centrally placed a little to the left in the picture, supported by a large white pillow. A woman sits to the right of the bed. The girl's nearly translucent face is drawn in profile against the white pillow, in contrast to the woman's dark appearance with bowed head and averted face. The woman, weighed down by grief, holds the sick child by the hand. It appears as though she is seeking comfort from the child.

The girl's gaze is drawn towards the fluttering curtain to the right in the picture. Does it perhaps express sadness and longing – for the world outside or for the approaching afterlife? The colour scheme consists mainly of vivid shades of green and red. The girl's red hair juxtaposes the green of her attire and the wall behind her. The red colour is repeated in the contours and surface of the bedside table.

The Sick Child is considered today to be the first motif in The Frieze of Life, and represents a breakthrough in his art. As is typical for Munch, the picture is rooted in a personal memory, which – after being developed – ends up expressing a universal feeling of grief.

Edvard Munch worked on the symbolic motif *The Human Mountain* several times during his life, and the first two drawings were made as early as in 1897. One of them was created by tracing the image of the lithograph *Funeral March* from 1897: Munch copied the lithograph of the gloomy picture of humanity's march towards death with the help of tracing paper, and replaced the coffin with a male figure stretching his arms towards the sun on top of a mountain.

The human figures clamber up the steep cliff; some, unable to make the climb, fall back down. They remain lying in the foreground as motionless bodies and severed heads with horror-stricken expressions. The motif is about spiritual enlightenment delivered at the top of the mountain (which has been interpreted by many as worldly success), and about those who are unable to reach the top. The climbing and falling humans are the main focus of the picture.

In May 1909 Munch signed up for the competition for decorating the University's Aula. He immediately began to make rough drafts for the decorations, and *The Human Mountain* was depicted in several of them. In one of the paintings from 1909–10 he developed the motif in a triangular composition in a broad format, also giving the picture new content. The mountain's steep peak was moved to the background, and the man at the top is less focused. A plateau in the middle of the mountain is populated by reclining figures, some of them attempting to rise. To the left in the foreground, two naked women sit hunched over with grieving facial expressions, but the terror from the first drawing is no longer there. On the right, two figures are attempting to climb up to the plateau. The woman in the middle of the foreground has Munch's own features in other versions of *The Human Mountain*, but in this painting he presumably identifies with the contemplative man who sits with his head in his hands at the foot of the mountain. This figure has deep roots in art history, and is undoubtedly inspired by the works of other artists, such as *The Thinker* (1899) by Auguste Rodin and *The Master Builder* (1892) by Henrik Ibsen.

Munch sent a different painting with the same motif to the competition in March 1910, together with a sketch for *History*. *The Human Mountain* was refused. With the gruesome events of WWI as a back-drop, Munch made new drawings of *The Human Mountain*, together with the motifs *War* and *Peace and the Rainbow*. The large painting *The Human Mountain. Towards the Light* stems from the end of the 1920s. The picture's composition has once again been changed. The mountain occupies an even larger portion of the visual space, the figure on the top has been removed, and there are more people trying to make the ascent. The female figure at centre front is lifting a child. The contemplative man has been replaced with a kneeling male figure, not unlike depictions of the Titan Atlas from Greek mythology. An open landscape with a dramatic sky surrounds the mountain.

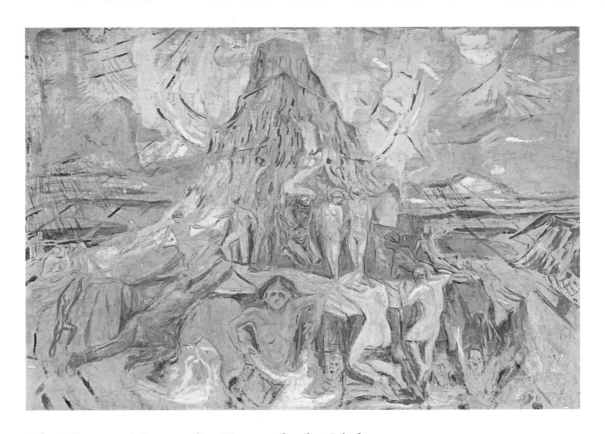

The Human Mountain. Towards the Light
(1927–29)
Oil on unprimed canvas
300 × 420 mm

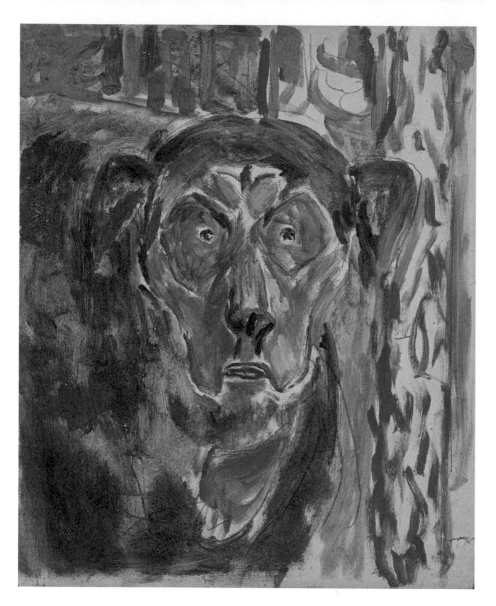

Dog's Head (1942)
Oil on wooden board
45.5 × 37 cm

In many families, dogs are much loved and treated like all the other members. They are included in the daily activities and allowed to sleep on the sofa. This is in contrast to the dog's place in public spaces. Dogs are less welcome in the workplace or cafés than previously.

Edvard Munch had many dogs. In 1910 he acquired his first, a terrier by the name of Fips. Later came Gordon Setters, St. Bernards, Rottweilers, additional terriers and, apparently, a Samoyed. It is not known how many dogs Munch had during the 33 years he lived with them, but we know that in periods he had several at the same time. He often used them as models when he painted. The dogs might be included as a compositional element together with humans, but Munch also made some remarkable studies of individual dogs, such as the portrait of this Rottweiler.

Munch was a masterful portrait painter of people. Portraits make an individual appear significant, and often include attributes that are particular to the subject. The same applies to Munch's portraits of dogs. They are individualised and provide the viewer with insight into their personality. What is particularly conspicuous is how meticulously Munch depicts the colours and markings on their fur. The ears and coat are also given attention. In this way it is possible to see the difference between dogs of the same breed, such as two St. Bernards he painted with tails in different colours.

This working method also characterises the portrait of the Rottweiler we see here. The black and brown features in the face and on the dog's tail are unique to this individual. The main focus in the painting, however, is on the frontal face. This angle makes the face look flat. The eyes are surrounded by round markings in the fur, making the eyes appear wide open as they encircle a foreshortened muzzle. Under the nose two small flews, or lips, are shown. The face is elongated and the jowls sag. The dog's head has taken on human features, almost resembling an old man who stares directly at the viewer, in alarm or resignation.

The painting was made in 1942, two years before Munch died. The aging artist demonstrates that he can still produce art that is stirring and energetic. The portrait of the dog is one of the highlights of the late period of Munch's oeuvre, together with paintings like *Self-Portrait. Between the Clock and the Bed* and *Starry Night*. A typical feature of his final years is a distinct interest in creating art that treats his own (and life's) impermanence. According to Munch's friend Christian Gierløff, the artist once said, "The older I become, the less difference I see between animals and humans". *Dog's Head* demonstrates the likeness he saw between animals and humans. The dog is Munch, and Munch is the dog. It has stopped in its tracks and stares out of the picture, at the world we inhabit. We look at Munch, and Munch looks back at us.

The descriptive title is redundant. All it does is make us focus on the most obvious figurative elements. Yes, it must be a self-portrait. Sad face, unreadable eyes seeming blind, corners of his mouth turned down, and the face rendered in a bizarre palette: orange only a shade darker than the wall behind it. Red, yellow and green, the latter in places that make little sense. His suit has the shimmering colours that make the fabric move, changeant, as in *Self-Portrait with a Bottle of Wine*. And indeed, he is standing in the narrow space between the clock and the bed. Behind the figure, a crowded display of paintings. Behind the door leading to the space beyond, a tall female nude. Many have commented on the symbolism of life and death in this work from the artist's old age. The blind clock that lacks hands and the bed, of the title, the bed waiting to become a death bed …

More than symbolism – which, if used exclusively, is a mode of reading that overlooks the artistic texture – what matters are the colour, brushwork and composition. The bedcover on the lower right proposes a direction for looking; a poetics of painting. Bare canvas, it only contains roughly painted cross-hatched black and red stripes. These are applied so that the plane we look at, where the bedspread falls down, seems flat, and the different pattern makes the upper part seem perspectival. But is that really so, or is it the shape of the bed that makes us assume this? An enticement to think. The pattern is so abstract, so different from the colours in the rest of the painting and thereby so dominant, that once we look at it, it seems the painting's most important feature.

The two pieces of furniture mentioned in that over-explicit title, with the narrowness of the space in between, may well solicit symbolic interpretations. But take the preposition "between" as the crucial word. It separates and binds; time and timelessness, life and death. But also, due to the striking bedspread/cross-hatching on bare canvas, "between" stands between two inseparable features of Edvard Munch's work, the integration of which has determined its radical modernity all through his career: figuration and abstraction. More emphatically than ever, Munch is here stating his refusal to choose between these, because his work rejects the opposition between them. This he has been doing throughout his career, already in the 1886 *Girl at the Piano*. He has experimented with colour, brushstrokes, merging flat and spatial effects, and more. But here, he does something stronger. He wants us to wonder: is that distinctive section on the lower right a bedspread or an abstract painting, accidentally migrated from the back room to the forefront? The pattern on the bedspread, or the canvas, is so deceptive, that without the figuration of the bed it would just be one abstract, sketchy, bi-coloured plane you can hang on your wall. A manifesto of "inbetweenness".

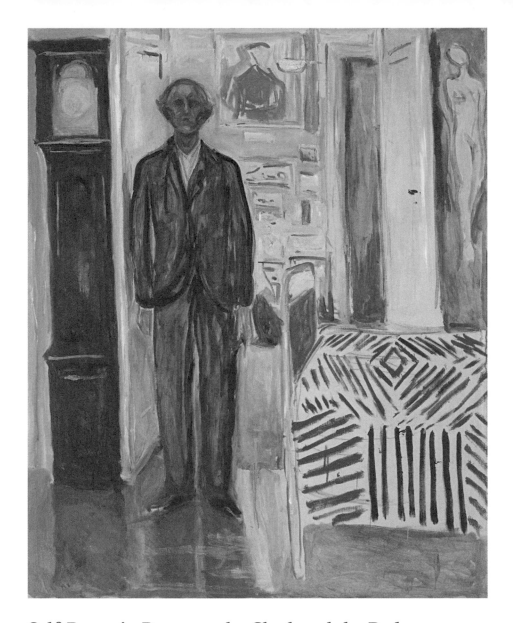

Self-Portrait. Between the Clock and the Bed
(1940–43)
Oil on canvas
149.5 × 120.5 cm

The texts in this book were written by the art historians below, and were first published in *Edvard Munch. Infinite* (MUNCH, 2021), which contains texts on 150 of Munch's works of art.

To delve deeper into the museum's collection of paintings, prints and drawings, and for Edvard Munch's biography, see munchmuseet.no. Edvard Munch's texts: eMunch.no

Published by MUNCH

Head of Publications: Josephine Langebrekke
Edtiorial Contributor: Karen Elizabeth Lerheim
Factual accuracy check: Lasse Jacobsen
Photos: Halvor Bjørngård and Ove Kvavik
Design: Jens Johan Tandberg

Editorial adaptation: MUNCH
The selection of works of art and texts in this
book are taken from *Edvard Munch. Infinite*
 Editor: Tor Eystein Øverås
 Published by MUNCH, 2021
 Editorial Committee: Ute Kuhlemann Falck,
 Trine Otte Bak Nielsen and Jon-Ove Steihaug

Front cover: *Vampyr* (1895)

End paper: *Self-Portrait à la Marat at the clinic in
Copenhagen* (1908–09). Silver gelatin develop out
paper, 82 × 87 mm

Translation from Norwegian by Francesca M.
Nichols: Texts by Hans Arentz, Kari J. Brandtzæg,
Magne Bruteig, Signe Endresen, Frank Høifødt,
Lasse Jacobsen, Trine Otte Bak Nielsen,
Ingeborg Winderen Owesen, Petra Pettersen,
Jon-Ove Steihaug, Sivert Thue and Gerd Woll

Typeface: LL Bradford (Lineto)
Print and binding: Livonia Print
Repro: JK Morris

Photo: Munchmuseet

© 2023 MUNCH, Oslo
www.munchmuseet.no

ISBN: 978-82-8462-009-1

MUNCH

INPEX Idemitsu Norge AS canica VIKING

AkerBP **Deloitte.** Multiconsult

Bergesen-stiftelsen SPAREBANKSTIFTELSEN DNB Talent Norge